ROYAL COURT

T0258649

Royal Court Theatre presents

SUGAR MUMMIES

by **Tanika Gupta**

First performance at the Royal Court Jerwood Theatre Downstairs,
Sloane Square, London on 5th August 2006.

First performance at the Octagon Theatre, Bolton on 12th September 2006.

First performance at Birmingham Repertory Theatre on 20th September 2006.

Supported by the
COLUMBIA FOUNDATION

National Poetry Competition 2006

Judges: John Burnside
Lee Harwood
Alice Oswald

First prize: £5,000
plus the opportunity to read with the
judges at the 2007 Ledbury Poetry Festival.
Second prize: £1,000
Third prize: £500
plus ten commendations of £50.

Closing date: 31 October 2006

For an entry form send an A5 SAE to
Competition Organiser (RC),
22 Betterton Street, London WC2H 9BX
or enter online at **www.poetrysociety.org.uk**
and click on the Poetry Shop.

THE INDEPENDENT
ON SUNDAY

Media sponsor of the National Poetry Competition

THE POETRY SOCIETY

SUGAR MUMMIES

by **Tanika Gupta**

Cast in order of appearance
Reefie **Victor Romero Evans**
Angel **Lorna Gayle**
Sly **Javone Prince**
Naomi **Vinette Robinson**
Andre **Marcel McCalla**
Antonio **Jason Frederick**
Maggie **Lynda Bellingham**
Kitty **Heather Craney**
Yolanda **Adjoa Andoh**

Director **Indhu Rubasingham**
Designer **Lez Brotherston**
Lighting Designer **Rick Fisher**
Sound Designer **Paul Groothuis**
Video Design **Mesmer**
Composer **Paul Englishby**
Assistant Director **Natascha Metherell**
Casting **Amy Ball**
Production Manager **Sue Bird**
Stage Manager **Rebecca Austin**
Deputy Stage Manager **Louise McDermott**
Assistant Stage Manager **Nafeesah Butt**
Stage Management Work Placement **Reasha Barnes**
Costume Supervisor **Jackie Orton**
Dialect Coach **Sally Hague**
Fight Director **Philip d'Orléans**

The Royal Court and Stage Management wish to thank the following for their help with this
production: Balliu and Southsea Deckchairs Ltd., Peter Jones, video equipment supplied by XL Video.

THE COMPANY

Tanika Gupta (writer)
Theatre includes: Voices on the Wind (National Theatre Studio); Skeleton (Soho); A River Sutra (Indosa); On the Couch with Enoch (The Red Room/BAC); The Waiting Room, Sanctuary (National); Inside Out (Clean Break); Fragile Land (Hampstead); Skater Boy (Theatre Royal Stratford East); Gladiator Games (Crucible/Theatre Royal Stratford East).
Adaptations include: Hobson's Choice (Young Vic); Good Woman of Setzuan (NT Education).
Television includes: Flight, A Suitable Boy, The Fiancée, The Rhythm of Raz, Bideshi, The Bill, EastEnders, Crossroads, Grange Hill, London Bridge, All About Me, Banglatown Banquet.
Radio includes: Asha, Badal and His Bike, Pankhiraj, The Bounty Hunter, Ananda Sananda, The Whispering Tree, The Queen's Retreat, Muse of Fusion, The Book of Secrets, The Trial of William Davidson, Stowaway, The Eternal Bubble, A Second Chance, Westway, The Parting, Chitra, Silver Street.
Awards include: Amnesty International Award 2005 for Best Radio Drama for Chitra; the Asian Woman of Achievement Award 2003 in the category of Arts and Culture; John Whiting Award for the Best New Play 2000 for The Waiting Room; EMMA for Best Television Production 1998 for Flight; The Fipa d'Argent Prize 1997 for The Whispering Tree.

Adjoa Andoh
For the Royal Court: Breath Boom.
Other theatre includes: Nights at the Circus, Pericles (Lyric Hammersmith); Blood Wedding (Almeida); His Dark Materials, Stuff Happens (National); Vagina Monologues (Old Vic); A Streetcar Named Desire (National Studio); The Dispute (RSC/Lyric Hammersmith); Starstruck (Tricycle); Tamburlaine, The Odyssey, Crowned with Fame (RSC); Death Catches the Hunter (Traverse); Love at a Loss (BAC/tour); Cloud Nine (Contact); The Snow Queen (Young Vic); Glory! (Lyric/Derby Playhouse/West Yorkshire Playhouse); Our Day Out (Birmingham); Pinchdice & Co., Lear's Daughters (Women's Theatre Group); Twice Over (Gay Sweatshop).
Television includes: Dr Who, Chopratown, Dalziel and Pascoe, Casualty, Macbeth, Jonathan Creek, Close Relations, Peak Practice, Thieftakers, Brass Eye, Twelve Angry Men, An Independent Man, Tomorrow People, Circle of Deceit, Health & Efficiency, Brittas Empire, EastEnders, The South Bank Show/Glory!.

Film includes: Every Time I Look at You, A Rather English Marriage, What My Mother Told Me, West Indian Women at War, A Short Film About Melons, The Missing Finger, I is a Long Memoried Woman, A Prayer Before Birth.

Lynda Bellingham
Theatre includes: Losing Louis (Trafalgar Studios); Catherine of Sienna (King's Head); Look No Hans (Aldwych); Strippers, Norman Is That You? (Phoenix); Noises Off (Savoy); Pygmalion, Richard II (Young Vic); Chapter Two (Lyric Hammersmith); Bordello (Queen's); The Sisters Rosensweig (Old Vic).
Television includes: Holby City, The Bill, Murder In Suburbia, All Star Comedy Show, The Last Detective, Midsomer Murders, Hogwash, Odd Socks, Dalziel and Pascoe, Happy Together, Hans Christian Andersen, My Uncle Silas, At Home With the Braithwaites, Reach for the Moon, The Bob Martin Show, Faith in the Future, Sisters Rosensweig, Martin Chuzzlewit, Second Thoughts, All Creatures Great and Small, Jackanory Playhouse, Filthy Rich and Catflap, Dr Who, The Gentle Touch, Angels, Murphy's Mob, McKenzie, Funny Man, The Pink Medicine Show, Scotch on the Rocks, Z Cars, Hazell, The Professionals, The Sweeney, Jimmy Tarbuck Series, General Hospital.
Film includes: Devil's Gate, Body Works, Don't Go Breaking My Heart, The Romanovs, The Scarlet Tunic, The Vision, Riding High, Waterloo Bridge Handicap, Sweeney One, Stand Up Virgin Soldiers.

Lez Brotherston (designer)
Theatre includes: Playing with Fire, Rosencrantz and Guildenstern are Dead (National); The Dark, Little Foxes (Donmar); Volpone, Design for Living, Woman of No Importance, Nude with Violin (Royal Exchange); The Crucible, David Copperfield (Crucible); Schippol the Plumber, Government Inspector (Greenwich); Bedroom Farce, A Midsummer Night's Dream, Alarms and Excursions, French and Saunders Live, Victoria Wood At It Again, Far Pavilions, Acorn Antiques, Tonight's the Night, My One and Only, Spend Spend Spend (West End); Brighton Rock (Almeida); Les Liaisons Dangereuses (Japan/Sadler's Wells); A Soldier's Tale (ROH); Edward Scissorhands (New Adventures); Play Without Words (National/New Adventures); The Car Man, Cinderella, Swan Lake, Highland Fling (Adventures in

Motion Pictures).
Opera includes: L'Elisir D'Amore (Grange Park Opera); La Somnambula (Teatro Municipale, Rio de Janeiro); Hansel and Gretel (Opera Zuid/Opera Northern Ireland); Cunning Little Vixen, Ariadne auf Naxos, Werther (Opera Zuid); Falstaff (Teatro Bellini, Sicily/Royal Danish Opera, Copenhagen).
Film includes: Letter to Brezhnev, Swan Lake, The Car Man.
Awards include: Tony Award for Swan Lake (AMP); Olivier Award for Outstanding Achievement in Dance for Set and Costume for Cinderella; Critics' Circle Award for outstanding achievement in design for dance.

Heather Craney
For the Royal Court: Stoning Mary.
Other theatre includes: Still Life/Astonished Heart (Liverpool Playhouse); Blue Remembered Hills (National Studio); Romeo and Juliet, All That Trouble That We Had (New Vic, Stoke); Passion Play (Comedy); Dangerous Corner (Watford Palace); Tess of the D'Urbervilles (JFK Rep); Death of an Elephant (Orange Tree).
Television includes: Ahead of the Class, The Bill, The Time Master, Silent Witness, Holby City.
Film includes: The Mark of Cain, Vera Drake, All or Nothing, Topsy Turvy, Drinking Crude, Loop.

Paul Englishby (composer)
Theatre includes: A Midsummer Night's Dream, Sejanus, Much Ado About Nothing, The Merchant of Venice, The Taming of the Shrew, The Tamer Tamed, All's Well That Ends Well (RSC); Yellowman, Anna in the Tropics (Hampstead); Longitude (Greenwich); Fabulation (Tricycle); Three Sisters, Romeo and Juliet (Chichester); Visitation (Oval House); Amnesia (Young Vic); Bedroom Farce (West End).
Concert Hall includes: Music in Motion, Byron, Violin Concerto, Short Symphony, Sonata for String Quartet, Dots for wind quintet, Lyrics for violin and cello, Don't Try This at Home for solo piano, Lullaby for flute and piano, The Child Ephemeral for organ, Sonnet VIII for tenor voice and string quartet, I am Music for school choirs and orchestra, Weep no More for strings, Everything is You for saxophone quartet.
Television includes: The Score, History of Football, Pictures on the Piano, Human Jungle, Hidden Voices, Living with the Enemy.
Film includes: (as composer) Confetti, Ten Minutes Older – The Trumpet, Ten Minutes Older – The Cello, The Enlightenment, Serial Thriller, Death of the Revolution; (as arranger/orchestrator) Captain Corelli's Mandolin, The Last Legion, Goal 2, Animal, The Alzheimer Case, Proof, Two Brothers, Birthday Girl, Hart's War, Charlotte Gray, Secret Passage, If Only, Love's Brother, The Feast of the Goat; (as MD) About a Boy, Captain Corelli's Mandolin, Hart's War, If Only, Alpha Male, The Feast of the Goat, Deseo, Love's Brother, Black Ball, Travaux.

Rick Fisher (lighting designer)
For the Royal Court: A Number, Far Away (and NY Theatre Workshop), My Zinc Bed, Via Dolorosa (and Broadway), The Old Neighborhood, Fair Game, Hysteria, The Changing Room, Rat in the Skull (Royal Court Classics), King Lear, Six Degrees of Separation (and Comedy Theatre), The Queen and I (and Vaudeville Theatre), Serious Money, Bloody Poetry, Three Birds Alighting on a Field, A Mouthful of Birds.
Other theatre includes: Billy Elliot, the Musical (Victoria Palace); Tin Tin (Barbican); The Bee (Soho Theatre); Jerry Springer The Opera (Cambridge); Old Times, Lobby Hero, A Boston Marriage (Donmar/New Ambassadors); A Russian in the Woods (RSC); Mother Clap's Molly House (National/Aldwych); Star Quality (Apollo); Napoleon (Shaftesbury); A Winter's Tale, Albert Speer, Blue/Orange, Widowers' Houses, Flight, Death of a Salesman, Machinal (National); An Inspector Calls (National/Garrick/Aldwych/Broadway); The Hunchback of Notre Dame (Berlin).
Dance includes: Swan Lake (Sadler's Wells/Los Angeles/Broadway), Cinderella (Piccadilly/Los Angeles).
Opera includes: Betrothal in a Monastery (Glyndebourne); Wozzeck (ROH); Fiery Angel, Turandot (Bolshoi); Peter Grimes, La Sonnambula, Clemenza di Tito, Traviata, Egyptian Helen, Wozzeck (Santa Fe); La Vestale, Verdi Requiem, Dr Ox's Experiment, Fairy Queen (ENO); Flying Dutchman (Bordeaux); Gloriana, Medea, La Boheme (Opera North).
Awards include: Olivier Award for Hysteria (Royal Court), Lady in the Dark, Chips with Everything, Machinal (National), Moonlight (Almeida); Tony Award for An Inspector Calls (Broadway).
Rick is Chairman of the Association of Lighting Designers.

Jason Frederick
For the Royal Court: Fallout.
Other theatre includes: Hello Dad (Soho);
Fearless Crew, The Weaker Sex, Burning
Ambitions, Sparkleshark (Riverside); Lucid,
S.K.I.P. (Lyric Hammersmith).
Television includes: Silent Witness, Ahead of the
Class, Take My Heart, Snowman, The Message.
Film includes: Crusade in Jeans, Goal.

Lorna Gayle
For the Royal Court: Blest Be The Tie, Almost
Nothing.
Other theatre includes: The Crucible (RSC); To
Kill a Mockingbird (Salisbury Playhouse);
Compact Failure (Clean Break tour); Stepping
Out (Southwold Summer Theatre).
Television includes: EastEnders, My Hero,
Canterbury Tales, The Bill.
Film includes: Love and Other Disasters, Baby
Mother.
Radio includes: Partial Eclipse of the Heart.

Paul Groothuis (sound designer)
Theatre includes: Acorn Antiques (West End);
Edward Scissorhands (Sadler's Wells); Anything
Goes, My Fair Lady (National/Drury Lane/UK
tour); Oklahoma! (National/Lyceum and
Gershwin Theatre, New York); Carousel
(National/West End/Tokyo); A Funny Thing
Happened on the Way to the Forum, Stuff
Happens, The House of Bernarda Alba, Buried
Child, and Henry IV part 1&2, The Oedipus
Plays, Summerfolk, The Merchant of Venice,
Candide, His Dark Materials, Edmond, Henry V,
A Streetcar Named Desire, The Coast of
Utopia, Oh What a Lovely War, A Little Night
Music, Lady In The Dark, Guys & Dolls, Under
Milk Wood, Sunday In The Park With George,
Sweeney Todd, The Wind in the Willows, The
Night of the Iguana, The Shaughraun (National);
The King & I (London Palladium/UK tour);
Endgame (Albery); The Nutcracker! (Sadler's
Wells/UK, US, Japan, Korea tours); Mermaids
(Dublin); Oliver! (Palladium).
Awards include: Live! Magazine Sound Designer
of the Year Award 1999, for Oklahoma! and Oh
What A Lovely War.
Paul is Associate of the National Theatre Sound
Department.

Mesmer (video design)
For the Royal Court: Hitchcock Blonde, A Girl
in a Car with a Man.
Other theatre includes: The Powerbook, Coast
of Utopia, The Duchess of Malfi, Jerry Springer
the Opera, Henry V, Jumpers, His Dark Materials
(National); The Woman in White (Palace/
Marquis, New York); Wagner's Ring Cycle
(ROH); Julius Caesar (Barbican); Richard II (Old
Vic); Measure for Measure (Complicite).
Mesmer's Dick Straker is Technical Associate of
the National.

Natascha Metherell (assistant director)
As assistant director: Midsummer Night's
Dream (Glyndebourne Festival Opera); Bake
For One Hour (ENO); The Trouble with Asian
Men (ArtsDepot); The Soldier's Tale, Eugene
Onegin, La Traviata, Macbeth (ROH); A Servant
to Two Masters (Brockley Jack); Exclusive Yarns
(Wimbledon Studio); Sotoba Komachi, The
Damask Drum (Greenwich Playhouse).
As director: Distortion (Lyric Hammersmith);
Kickaround (Jerwood Space); The Wedding
Dress (Gallery 32); Miss Julie (Greenwich
Playhouse).

Marcel McCalla
For the Royal Court: Fallout, The One with the
Oven.
Other theatre includes: Blue Orange (Watford
Palace); Who Killed Mr Drum (Riverside); Little
Sweet Thing (Wolsey, Ipswich); Oliver Twist
(Palladium).
Television includes: The Bill, Footballers Wives,
Grange Hill, My Wonderful Life.
Film includes: Rehab, The Big Finish.

Javone Prince
For the Royal Court: 93.2FM.
Other theatre includes: Burn/Chatroom/
Citizenship (National); Raisin in the Sun (Young
Vic/tour); Car Thieves (Birmingham); Titus
Andronicus, Richard III, Measure for Measure
(RSC).
Television includes: Little Miss Jocelyn, What's
Going On, Murder Prevention, My Family.
Film includes: The Tiger and the Snow,
Dommeren, Manderlay.
Radio includes: Lacy's War, Small Island.

Vinette Robinson
For the Royal Court: 50 Readings, Grendon
Prison Project, Square Peg, Giddy Little Kippers.
Other theatre includes: Paradise Lost, Speaking
Like Magpies, Sejanus, A New Way to Please
You, Thomas More (RSC); Measure for Measure
(National).
Television includes: Casualty, Blue Murder,

Between the Sheets, Always and Everyone, Doctors, Fat Friends, Comin Attcha, Cold Feet, This is Personal, The Ward, The Cops, City Central.
Film includes: Imagine Me and You, Vera Drake.

Victor Romero Evans

Theatre includes: Hedda Gabler (Young Vic); The Big Life (Apollo/Theatre Royal Stratford East); Moon on a Rainbow Shawl (Nottingham Playhouse/tour); Ragamuffin (UK Arts International); Abyssinia (Tiata Fahodzi); One Love (Lyric Hammersmith); The Pan Beaters (Greenwich); Pinchy Cobi & Seven Duppie, Pecong (Tricycle); The Posse Comedy Sketches, Welcome Home Jacko (Theatre Royal Stratford East); The Man Who Lift Up the World (Battimamzel Productions); Sixty-Five with a Bullet, Redemption Song, One Rule, Mama Dragon (Black Theatre Co-op); Beef No Chicken, Dog (Black Theatre Forum); Nine Nights (Albany); Tewodros (Tara Arts); Job Rocking (Riverside); Tooth of Crime (Bush); Polly (Cambridge).
Television includes: Holby City, Black History, Magic Grandad, Doctors, Alistair McGowan's Big Impression, Judge John Deed, Storm Damage, Black Firsts, Get Up Stand Up, Holding On, Euro Cop, Billy's Christmas Angels, Party at the Palace, No Problem!, The Gentle Touch, Maids the Mad Shooter, Black on Black.
Film includes: Old Street, Carnival, Marked for Death, The Book Liberator, Runners, Burning an Illusion, Babylon, Class of Miss McMichael.
Radio includes: A House for Mr Biswas, The Big Life, So Long a Letter, English Rose, The Dragon Can't Dance, The Darkest Eye, In Praise of God, English One to One, A Midsummer Night's Dream, Gunchester, Ragamuffin, The Last Seed.

Indhu Rubasingham (director)
For the Royal Court: Clubland, Lift Off, The Crutch.
Other theatre includes: Fabulation, Starstruck (Tricycle); The Morris(Liverpool Everyman); Yellowman (Hampstead/Liverpool Everyman); Anna in the Tropics (Hampstead); Romeo and Juliet (Chichester Festival Theatre); The Misanthrope, The Secret Rapture (The Minerva, Chichester); The Waiting Room (National); The Ramayana (National/Birmingham Repertory); Time of Fire, Kaahini (Birmingham Repertory); A River Sutra (Three Mill Island Studios); Shakuntala, Sugar Dollies (Gate); The No Boys' Cricket Club, Party Girls, D'Yer Eat With Yer Fingers?! And D'Yer Eat With Yer Finger?! - The Remix (Theatre Royal Stratford East); A Doll's House (Young Vic Studio).
As associate director: Bombay Dreams.
Opera includes: Another America (Sadler's Wells).
Indhu is Associate Director at the Young Vic.

THE ENGLISH STAGE COMPANY
AT THE ROYAL COURT

The English Stage Company at the Royal Court opened in 1956 as a subsidised theatre producing new British plays, international plays and some classical revivals.

The first artistic director George Devine aimed to create a writers' theatre, 'a place where the dramatist is acknowledged as the fundamental creative force in the theatre and where the play is more important than the actors, the director, the designer'. The urgent need was to find a contemporary style in which the play, the acting, direction and design are all combined. He believed that 'the battle will be a long one to continue to create the right conditions for writers to work in'.

Devine aimed to discover 'hard-hitting, uncompromising writers whose plays are stimulating, provocative and exciting'. The Royal Court production of John Osborne's Look Back in Anger in May 1956 is now seen as the decisive starting point of modern British drama and the policy created a new generation of British playwrights. The first wave included John Osborne, Arnold Wesker, John Arden, Ann Jellicoe, N F Simpson and Edward Bond. Early seasons included new international plays by Bertolt Brecht, Eugène Ionesco, Samuel Beckett and Jean-Paul Sartre.

The theatre started with the 400-seat proscenium arch Theatre Downstairs, and in 1969 opened a second theatre, the 60-seat studio Theatre Upstairs. Some productions transfer to the West End, such as My Name is Rachel Corrie, Terry Johnson's Hitchcock Blonde, Caryl Churchill's Far Away and Conor McPherson's The Weir. Recent touring productions include Sarah Kane's 4.48 Psychosis (US tour) and Ché Walker's Flesh Wound (Galway Arts Festival). The Royal Court also co-produces plays which transfer to the West End or tour internationally, such as Conor McPherson's Shining City (with Gate Theatre, Dublin), Sebastian Barry's The Steward of Christendom and Mark Ravenhill's Shopping and Fucking (with Out of Joint), Martin McDonagh's The Beauty Queen Of Leenane (with Druid), Ayub Khan Din's East is East (with Tamasha).

Since 1994 the Royal Court's artistic policy has again been vigorously directed to finding and producing a new generation of playwrights. The writers include Joe Penhall, Rebecca Prichard, Michael Wynne, Nick Grosso, Judy Upton, Meredith Oakes, Sarah Kane, Anthony Neilson, Judith Johnson, James Stock, Jez Butterworth, Marina Carr, Phyllis Nagy, Simon Block, Martin McDonagh, Mark Ravenhill, Ayub Khan Din, Tamantha Hammerschlag, Jess Walters, Ché Walker,

photo: Stephen Cummiiskey

Conor McPherson, Simon Stephens, Richard Bean, Roy Williams, Gary Mitchell, Mick Mahoney, Rebecca Gilman, Christopher Shinn, Kia Corthron, David Gieselmann, Marius von Mayenburg, David Eldridge, Leo Butler, Zinnie Harris, Grae Cleugh, Roland Schimmelpfennig, Chloe Moss, DeObia Oparei, Enda Walsh, Vassily Sigarev, the Presnyakov Brothers, Marcos Barbosa, Lucy Prebble, John Donnelly, Clare Pollard, Robin French, Elyzabeth Gregory Wilder, Rob Evans, Laura Wade, Debbie Tucker Green and Simon Farquhar. This expanded programme of new plays has been made possible through the support of A.S.K. Theater Projects and the Skirball Foundation, The Jerwood Charity, the American Friends of the Royal Court Theatre and (in 1994/5 and 1999) the National Theatre Studio.

In recent years there have been record-breaking productions at the box office, with capacity houses for Joe Penhall's Dumb Show, Conor McPherson's Shining City, Roy Williams' Fallout and Terry Johnson's Hitchcock Blonde.

The refurbished theatre in Sloane Square opened in February 2000, with a policy still inspired by the first artistic director George Devine. The Royal Court is an international theatre for new plays and new playwrights, and the work shapes contemporary drama in Britain and overseas.

The Royal Court's long and successful history of innovation has been built by generations of gifted and imaginative individuals. In 2006, the company is celebrating its 50th Anniversary. The event is an important landmark for the performing arts in Britain and the company plans to deliver an extraordinary year of celebration and commemoration. For information on the many exciting ways you can help support the theatre, please contact the Development Department on 020 7565 5079.

AWARDS FOR THE ROYAL COURT

Martin McDonagh won the 1996 George Devine Award, the 1996 Writers' Guild Best Fringe Play Award, the 1996 Critics' Circle Award and the 1996 Evening Standard Award for Most Promising Playwright for The Beauty Queen of Leenane. Marina Carr won the 19th Susan Smith Blackburn Prize (1996/7) for Portia Coughlan. Conor McPherson won the 1997 George Devine Award, the 1997 Critics' Circle Award and the 1997 Evening Standard Award for Most Promising Playwright for The Weir. Ayub Khan Din won the 1997 Writers' Guild Awards for Best West End Play and New Writer of the Year and the 1996 John Whiting Award for East is East (co-production with Tamasha).

Martin McDonagh's The Beauty Queen of Leenane (co-production with Druid Theatre Company) won four 1998 Tony Awards including Garry Hynes for Best Director. Eugene Ionesco's The Chairs (co-production with Theatre de Complicite) was nominated for six Tony awards. David Hare won the 1998 Time Out Live Award for Outstanding Achievement and six awards in New York including the Drama League, Drama Desk and New York Critics Circle Award for Via Dolorosa. Sarah Kane won the 1998 Arts Foundation Fellowship in Playwriting. Rebecca Prichard won the 1998 Critics' Circle Award for Most Promising Playwright for Yard Gal (co-production with Clean Break).

Conor McPherson won the 1999 Olivier Award for Best New Play for The Weir. The Royal Court won the 1999 ITI Award for Excellence in International Theatre. Sarah Kane's Cleansed was judged Best Foreign Language Play in 1999 by Theater Heute in Germany. Gary Mitchell won the 1999 Pearson Best Play Award for Trust. Rebecca Gilman was joint winner of the 1999 George Devine Award and won the 1999 Evening Standard Award for Most Promising Playwright for The Glory of Living.

In 1999, the Royal Court won the European theatre prize New Theatrical Realities, presented at Taormina Arte in Sicily, for its efforts in recent years in discovering and producing the work of young British dramatists.

Roy Williams and Gary Mitchell were joint winners of the George Devine Award 2000 for Most Promising Playwright for Lift Off and The Force of Change respectively. At the Barclays Theatre Awards 2000 presented by the TMA, Richard Wilson won the Best Director Award for David Gieselmann's Mr Kolpert and Jeremy Herbert won the Best Designer Award for Sarah Kane's 4.48 Psychosis. Gary Mitchell won the Evening Standard's Charles Wintour Award 2000 for Most Promising Playwright for The Force of Change. Stephen Jeffreys' I Just Stopped by to See the Man won an AT&T: On Stage Award 2000.

David Eldridge's Under the Blue Sky won the Time Out Live Award 2001 for Best New Play in the West End. Leo Butler won the George Devine Award 2001 for Most Promising Playwright for Redundant. Roy Williams won the Evening Standard's Charles Wintour Award 2001 for Most Promising Playwright for Clubland. Grae Cleugh won the 2001 Olivier Award for Most Promising Playwright for Fucking Games.

Richard Bean was joint winner of the George Devine Award 2002 for Most Promising Playwright for Under the Whaleback. Caryl Churchill won the 2002 Evening Standard Award for Best New Play for A Number. Vassily Sigarev won the 2002 Evening Standard Charles Wintour Award for Most Promising Playwright for Plasticine. Ian MacNeil won the 2002 Evening Standard Award for Best Design for A Number and Plasticine. Peter Gill won the 2002 Critics' Circle Award for Best New Play for The York Realist (English Touring Theatre). Ché Walker won the 2003 George Devine Award for Most Promising Playwright for Flesh Wound. Lucy Prebble won the 2003 Critics' Circle Award and the 2004 George Devine Award for Most Promising Playwright, and the TMA Theatre Award 2004 for Best New Play for The Sugar Syndrome.

Richard Bean won the 2005 Critics' Circle Award for Best New Play for Harvest. Laura Wade won the 2005 Critics' Circle Award for Most Promising Playwright and the 2005 Pearson Best Play Award for Breathing Corpses. The 2006 Whatsonstage Theatregoers' Choice Award for Best New Play was won by My Name is Rachel Corrie.

The 2005 Evening Standard Special Award was given to the Royal Court 'for making and changing theatrical history this last half century'.

ROYAL COURT BOOKSHOP

The Royal Court bookshop offers a range of contemporary plays and publications on the theory and practice of modern drama. The staff specialise in assisting with the selection of audition monologues and scenes. Royal Court playtexts from past and present productions cost £2.

The Bookshop is situated in the downstairs ROYAL COURT BAR.

Monday–Friday 3–10pm

Saturday 2.30–10pm

For information tel: 020 7565 5024

or email: bookshop@royalcourttheatre.com

PROGRAMME SUPPORTERS

The Royal Court (English Stage Company Ltd) receives its principal funding from Arts Council England, London. It is also supported financially by a wide range of private companies, charitable and public bodies, and earns the remainder of its income from the box office and its own trading activities.

The Genesis Foundation supports the Royal Court's work with International Playwrights.

Archival recordings of the Royal Court's Anniversary year are made possible by Francis Finlay.

The Skirball Foundation funds a Playwrights' Programme at the theatre. The Artistic Director's Chair is supported by a lead grant from The Peter Jay Sharp Foundation, contributing to the activities of the Artistic Director's office. Over the past nine years the BBC has supported the Gerald Chapman Fund for directors.

The Jerwood Charity supports new plays by new playwrights through the Jerwood New Playwrights series.

We've always been happy to be less famous than our clients

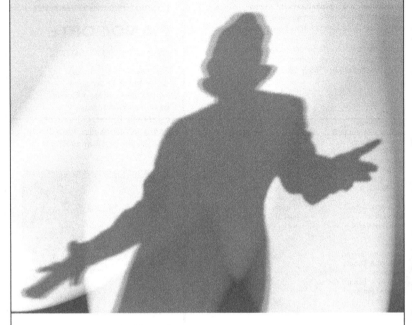

First published in 2006 by Oberon Books Ltd
521 Caledonian Road, London N7 9RH
Tel: 020 7607 3637 / Fax: 020 7607 3629
e-mail: info@oberonbooks.com
www.oberonbooks.com

Sugar Mummies © Tanika Gupta, 2006

Reprinted in 2015

A catalogue record for this book is available from the British
Library.

Cover image by AKA

PB ISBN: 978-1-84002-655-9
E ISBN: 978-1-84943-842-1

Characters

ANGEL
48 year old Jamaican woman,
masseuse and hair braider on the beach

REEFIE
50 year old Rastafarian, experienced gigolo,
Yolanda's lover

KITTY
38 year old white school teacher

SLY
street wise gigolo, 22 years old

ANDRE
grill chef at the hotel, 24 years old, Angel's son

ANTONIO
17 year old hotel staff who puts out sunbeds

NAOMI
mixed race woman, in her late twenties

YOLANDA
American woman in her early fifties

MAGGIE
white woman in her fifties

ACT ONE

Scene 1

We hear the sound of the waves lapping gently in a calm bay. The sun rises on a tropical beach in Jamaica with white sands and palm trees – the perfect beach.

A white woman, KITTY (thirty-eight), is lying flat out on a sunbed sunbathing.

REEFIE enters. He is a Rasta man in his early fifties, good looking, slim built and lithe. He is busy building a boat in the background, going to and fro, fetching wood etc. He carries a machete with him.

ANGEL, a middle aged Jamaican woman, enters carrying a large heavy bag. She turns and waves at REEFIE.

ANGEL unlocks a small beach hut and rakes the sand out front. She puts up a sign: 'ALOE VERA MASSAGES AND HAIR BRAIDING'.

She stands and looks out to sea. She looks tired. REEFIE approaches her with a flask and pours her a hot drink from it. She takes it wordlessly and drinks.

REEFIE: Look tired.

ANGEL: Early start.

REEFIE: Long journey from de mountains.

ANGEL: Yeah mon.

REEFIE: Tiny doin' okay?

ANGEL: Fifteen an' him want to pack in school. Him wan earn him living like him big brother.

REEFIE: Him earn better livin' wid some school behind him.

ANGEL: Me tell him. Andre tell him. Cyan tell de buoy nuttin'.

A plane flies overhead.

ANGEL: Boat comin' on?

REEFIE: Comin' on good.

ANGEL: (*Laughs.*) Den what? You sail off into de sunset?

REEFIE: (*Teases.*) You come wid me. We be like Adam and Eve in Paradise.

ANGEL: Adam and Eve dem fall from grace.

REEFIE: We can change de story.

ANGEL: (*Laughs.*) What about all your women? Dey come after me and try drown me.

REEFIE: Me jus' wan' me a nice island girl.

ANGEL pushes REEFIE playfully. They laugh.

ANGEL: You hear about my man?

REEFIE: Me hear.

ANGEL: Him a walking duppy. Him die soon.

REEFIE looks at ANGEL with sympathy. She looks sad. ANGEL hands back her cup to REEFIE. He pads away through the sand back to his boat. ANGEL sits and waits for custom.

NAOMI enters. She is a mixed race woman in her late twenties, in a swimsuit. She stands for a moment and stares out to sea in wonder.

We hear the distant call of hawkers calling out their wares.

'Coconut, pineapple, mangoes, bananas
Cigarettes, Marlborough light, cigarettes.
Coconut, pineapple, mangoes, bananas.'

NAOMI pulls out a camera and takes a picture of the sea.

SLY walks by.

SLY: Pssst.

NAOMI ignores him.

Pssst. Hey. Pretty lady.

SLY beckons NAOMI to him.

NAOMI looks away. SLY looks around surreptitiously and approaches NAOMI.

What's your name?

NAOMI: (*Resigned.*) Naomi.

SLY crouches next to NAOMI.

SLY: Sly.

He puts out his hand. NAOMI shakes hands. SLY holds on to her hand a little too long.

Wanna go jet-ski?

NAOMI: No…thank you.

SLY: Parasailing?

NAOMI: No…

SLY: How 'bout a glass bottom boat? I tek you out to the coral reef. We can go snorkel?

NAOMI: No…maybe another time.

SLY: You interested in a lickle weed? Ready-made, Bob
 Marley cones…only five dollars. Look.

SLY reaches into his pocket.

NAOMI: No…

SLY: Ten dollar bags. Island weed. De best.

NAOMI looks away.

What else I can offer you?

NAOMI: Nothing – really.

SLY: You're a pretty lady. Maybe we can walk together on
 de beach?

*ANDRE appears in the background, dressed in a white apron,
wearing a chef's hat. SLY clocks ANDRE.*

ANDRE: Cho Sly. Don't hassle de tourists.

SLY: No problem man.

SLY stands up and looks down at NAOMI.

Naomi. Nice meetin' you.

He touches fists with NAOMI.

One love.

*SLY saunters off. NAOMI turns and smiles at ANDRE who
doesn't smile back. Instead, he gets busy cleaning surfaces in
his grill/bar. He puts out a large black board with the names
of all the cocktails and another one with the menu.*

*He waves at ANGEL who waves back before disappearing
into her hut.*

ANTONIO, a very young Jamaican man (seventeen) with 'STAFF' emblazoned on his T-shirt, appears behind her, carrying a sunbed and a towel.

ANTONIO: Miss. You want a sunbed? Towel?

NAOMI: Oh hi. Yes please.

ANTONIO expertly snaps open the sunbed, brushes off the sand and lays it down for NAOMI, near the sunbathing KITTY.

Thank you…

ANTONIO: Yeah mon.

NAOMI sits down gingerly.

ANTONIO places the towel on the back of the sunbed for her. He looks at NAOMI with interest.

This your first time or you hab family here?

NAOMI: Erm…my first time…

ANTONIO: My name is Antonio. Welcome to Jamaica. Respect. Anyt'ing you want. I be here.

ANTONIO touches fists with NAOMI.

NAOMI: Thank you.

ANTONIO: Me pleasure.

NAOMI settles down on the sunbed and continues to savour the sea.

MAGGIE, a woman in her fifties, walks down to the beach and stands looking out to sea. Her grey hair has been braided back into cane row. She smiles at NAOMI. ANTONIO is by her side immediately with a sunbed. He snaps open the sunbed. MAGGIE sits down.

MAGGIE: Thank you.

ANTONIO: Me pleasure. Welcome to Jamaica.

As ANTONIO exits, MAGGIE watches after him with interest.

MAGGIE: Sleep well?

NAOMI: Not at first. Those cicadas are so noisy!

MAGGIE: Nothing you can do about them.

NAOMI: And my room was boiling.

MAGGIE: What's wrong with the air con?

NAOMI: Gives me a headache.

MAGGIE: You just lay there sweltering?

NAOMI laughs apologetically.

NAOMI: Dropped off at some point though, then woke up early. Went for a walk along the beach.

MAGGIE: Beautiful isn't it?

NAOMI: Breathtaking. Think I'll take a quick dip.

MAGGIE: Go for it.

NAOMI exits towards the sea.

MAGGIE settles down on her sunbed, gets on with the business of taking out magazines from her bag etc. KITTY sits up on her sunbed and starts applying some sun cream to her body. For a while the two women ignore each other.

MAGGIE: Hi.

KITTY: Oh – hi.

MAGGIE: Don't you love it here?

KITTY: My third visit!

MAGGIE: My first time. Usually travel on my own. Bit expensive here. Not like the Dominican Republic. Everything's dirt cheap out there. Still, the Jamaicans are more laid back. I like that. And I love the accent.

Beat.

KITTY: First thing I did when I arrived yesterday was to go for a massage.

KITTY points in ANGEL's direction

Try her out. She's great.

MAGGIE looks across at ANGEL.

MAGGIE: Might just do that. Thanks for the tip. By the way, name's Maggie.

KITTY: Kitty.

MAGGIE: From London. You?

KITTY: Manchester.

MAGGIE: My brother lives there.

KITTY: Really? Where?

MAGGIE: East Didsbury.

KITTY: That's where I live!

MAGGIE: Rathen Road.

KITTY: Round the corner from me!

MAGGIE: Small world.

KITTY: How funny.

They both soak up the sun for a bit.

KITTY: When did you arrive?

MAGGIE: Yesterday afternoon. Went straight along to Rik's Café.

KITTY gets excited at this information.

KITTY: Rik's café?

MAGGIE: Yeah.

KITTY: Best sunsets there.

MAGGIE: Great views all round.

KITTY: (*Laughs.*) Oh yes.

Beat.

Watch all those men diving off the cliff?

MAGGIE: They're amazing.

KITTY: Hmmm…

MAGGIE: Climbing up those rock faces like crabs then doing all these somersaults in the air before plunging into the depths.

KITTY: Incredibly agile.

MAGGIE: Beautiful bodies.

KITTY: Beautiful bodies.

MAGGIE: Flat stomachs, muscles all over…

KITTY: Watch them and you kind of… How did you hear about this place?

MAGGIE: Word of mouth – Lonely Planet…

KITTY: Men here certainly know how to treat a lady. They love us!

MAGGIE: Least they pretend to.

KITTY: They're so sweet.

MAGGIE: And really black.

KITTY: Blue black.

MAGGIE: Nice smiles – white, white teeth against black skin.

KITTY: Tall and strong.

MAGGIE: Big, luscious, kissable lips.

KITTY: Real men.

MAGGIE: Much bigger than white men. The Big Bamboo.

KITTY: Jamaican Steel.

They both laugh.

And it's not over in two minutes. They can keep going all night.

MAGGIE: And they've got the rhythm – so they can move – so athletic.

KITTY: Such supple bodies.

MAGGIE: 'Once you've had black, you never go back.'

They both laugh happily.

KITTY: Pretty much get the pick of the bunch. They don't look at your wrinkles – just at your face. They like eyes. They're so romantic.

MAGGIE: Know how to talk the talk.

KITTY: Wouldn't do this back home.

MAGGIE: It's not illegal to have a good time.

KITTY: I know…but still.

MAGGIE: You're on holiday! Enjoy yourself!

KITTY: I have every intention of enjoying myself.

MAGGIE: Good.

KITTY lays back down on her sunbed and continues with her sunbathing.

NAOMI re-enters. She is wet from the sea. MAGGIE passes her towel to her and NAOMI towels herself dry.

YOLANDA, a fifty year old American woman, walks out in a flashy swimsuit, looks out to sea and sighs deeply.

YOLANDA: I think I just came.

NAOMI exchanges an amused look with MAGGIE. YOLANDA turns and looks at ANDRE.

There's my man – Andre!

ANDRE: (*Smiles.*) Yolanda.

YOLANDA: You're grilling me lobster for lunch, you hear?

ANDRE: No problem.

YOLANDA: Hey, where's Antonio? (*Calls out.*) Antonio! Sweetcakes!

ANTONIO bustles out.

ANTONIO: Yolanda, you back!

YOLANDA: Yep.

ANTONIO: Good to see you. Respect.

YOLANDA: Hey, you grown taller since last time we met?

ANTONIO laughs. YOLANDA and ANTONIO touch fists.

ANTONIO: Sunbed? Towels?

YOLANDA: Yep.

> *ANTONIO bustles off. YOLANDA picks up some confetti from the sand.*

Looks like someone got themselves married again.

NAOMI: Bride was dressed in a very skimpy white bikini.

YOLANDA: Should be grateful she was wearing something. They got themselves a nudist colony down there (*She points.*) in Bloody Bay. Locals call it 'the zoo'.

NAOMI: That nudist stuff, really doesn't turn me on. All those bits…

MAGGIE: Oh I don't know – it can be quite liberating.

YOLANDA: European folk sure do like baring their flesh.

> *MAGGIE looks away slightly annoyed.*

You folk from England?

NAOMI: Yeah. London.

YOLANDA: I could tell from the accent.

MAGGIE: And you're from the States?

YOLANDA: Sure am.

MAGGIE: (*Sarcastic.*) I could tell from the accent.

> *ANTONIO returns with a sunbed. He pulls it out, dusts the sand off and lays it down for YOLANDA. YOLANDA sits down.*

ANTONIO: Yolanda, lookin' good.

YOLANDA: Thank you sweetcakes. Hey, hey, take those shades off, Tony-o…

ANTONIO takes off his shades.

See those eyes girls? Ever see such beautiful eyes?

NAOMI glances at ANTONIO's eyes. He flutters his eyelashes.

NAOMI: Curly eyelashes!

MAGGIE: Not fair.

YOLANDA: Tony-o, honey cakes – you make an old woman very happy.

ANTONIO: Yolanda is forever young. Ever get tired of your boy, you be tellin' me.

YOLANDA: Don't get fresh with me.

ANTONIO: Me cyan help it. Yolanda mek Antonio sweat.

YOLANDA shrieks with laughter. ANTONIO and YOLANDA slap palms. NAOMI watches on and smiles. ANTONIO bustles off again. MAGGIE watches him go.

MAGGIE: Such a sweet kid.

YOLANDA: Ain't he just?

ANDRE appears by YOLANDA's side with a cocktail.

Dirty banana?

ANDRE: Yeah mon. Your usual.

YOLANDA: Just put it on my tab. Oh, and here…

YOLANDA fishes around in her purse and hands over a small tip.

ANDRE: Tanks.

ANDRE turns to NAOMI and MAGGIE

How about you Ladies? Can I get you a drink?

NAOMI: No, I'm fine. Thanks.

MAGGIE: Maybe later.

SLY walks by again. He stops when he sees YOLANDA.

SLY: Hey! My Size!

YOLANDA: Sly...according to you – all women are your size.

SLY: You is lookin' finger lickin' good. Like rice and peas and dumplin'.

YOLANDA: Why you always talk about food when you see me?

SLY: Me like de girl with de big batty. More to hold on to...

He grinds his hips suggestively.

YOLANDA: Don't you be trying to sweet talk me.

SLY: Yolanda...

YOLANDA: Old enough to be your mother. Look, there's a pretty girl next to me. Talk to her instead.

SLY: Me no wan' the kitten, me wan' the cat.

YOLANDA: Miiaowww!

They laugh.

NAOMI: (*To SLY.*) Oh, so now I'm not good enough for you? You men, so fickle.

SLY: Me no mean no disrespec' Naomi, (*Looks at MAGGIE.*) lady... So many pretty ladies, it turn me head.

NAOMI: (*Happy.*) Yeah, right...

SLY: (*To YOLANDA.*) How long you here for?

YOLANDA: Two weeks.

SLY: Hook up with de Lion yet?

YOLANDA: I'm waitin' on him.

SLY: If me see 'im, me tell 'im you here.

YOLANDA: No… I just want thinkin' time this morning.

SLY: Yolanda gettin' a lickle tired of the Lion?

YOLANDA: Yolanda's just fine.

SLY: You have your rest, me always here if you wan' some real sweet loving.

YOLANDA: Yeah, yeah…

SLY walks off again – on the lookout.

MAGGIE lays back on her sunbed. NAOMI can't help watching YOLANDA. She is fascinated by her.

NAOMI: So, you obviously come here a lot.

YOLANDA: Sure do. It's my sixteenth visit. You lookin' for anything in particular?

NAOMI: Needed a break.

YOLANDA: Uh-huh. Lot of women folk come here looking for a break.

NAOMI laughs.

NAOMI: I noticed.

YOLANDA: (*Knowing.*) Uh-huh.

NAOMI: I'm not here for…but gotta admit. Blokes here are gorgeous.

YOLANDA whoops and slaps palms with NAOMI. Then she makes a big deal of untying her sarong, adjusting her straps, sipping her drink, etc.

YOLANDA: Time to pay my respects to the Caribbean.

YOLANDA goes for a swim.

NAOMI: I was actually born here.

MAGGIE: That's why I had to bring you back.

NAOMI: Thanks Maggie.

MAGGIE: I just want you to have some fun. You deserve a change of scene. Actually, you deserve a good shag. Spoilt for choice. Look at these handsome men round here? Imagine having one of those rocking between your legs all night?

NAOMI: I guess it'd be one way of getting back to my roots.

MAGGIE loves this and laughs uproariously. NAOMI watches her amused.

It's good to see you so relaxed Aunty Mags.

MAGGIE: For Christ's sake don't call me Aunty...

NAOMI: (*Laughs.*) Whoops. Don't wanna cramp your style do I?

MAGGIE: Too right.

NAOMI: Hungry. Think I'll order some breakfast.

MAGGIE: I'll join you in a bit.

NAOMI exits. SLY walks past yet again. He clocks ANTONIO before sitting at some distance. ANTONIO clocks SLY's look and steps forward.

ANTONIO: Anyting you want, me be here.

MAGGIE: Really?

ANTONIO: Really.

MAGGIE: In that case…

MAGGIE fishes out her suntan lotion from her bag. She hands it to ANTONIO and lays on her front and undoes her bikini top. ANTONIO stands, a little surprised, clutching the suntan lotion.

What are you waiting for?

ANTONIO kneels by her sunbed and starts to rub the sun tan lotion into MAGGIE's back. He looks a bit nervous. SLY watches from a distance and smirks.

Nice strong hands.

ANTONIO: Tanks.

ANTONIO finishes rubbing suntan lotion into MAGGIE's back. MAGGIE rolls back over and does up her bikini. She rubs oil into her legs. ANTONIO stands by watching awkwardly. MAGGIE smiles at him.

MAGGIE: Thank you.

ANTONIO is uncertain what to do next. MAGGIE plugs in her walkman and lays back down. ANTONIO exits, passing SLY who makes a big show to ANTONIO of walking over to KITTY.

SLY: Pssst…Kitty Kat. Remember me?

KITTY: Oh…it's you…

SLY: I see you back dere – yesterday on de beach? You have a good massage?

SLY crouches by KITTY's sunbed. MAGGIE is still lying down but has one eye on the couple.

KITTY: Fantastic.

SLY: Angel's the best masseuse on de beach. She have de touch.

KITTY: All my aches and pains gone.

SLY: Me also have de touch.

KITTY: Oh…please…

SLY: I see you on de beach, prettiest ting I ever see. Ooohhh…

KITTY: (*Loving it.*) Stop it.

SLY: Me tink, if me can get a 'oman like dat….

KITTY: I'm not falling for your tricks.

SLY: What trick? Me trick you? No man!

KITTY: I know what you Jamaican boys are like.

SLY: Me see you for you. Me don't see you for what you got… Me cyan fake it. Me have to be real and you are real nice.

KITTY laughs.

You give Sly good vibes.

KITTY: Is that your name?

SLY: Yeah man. Respect.

He touches fists with KITTY. She hesitates and then touches fists with him.

You here on your own?

KITTY: Yes.

SLY: You need someone to look out for you.

KITTY: I know my way around.

SLY: But you so pretty you need someone to chase de dogs away.

KITTY: Thanks but – no.

SLY: You from Englan'?

KITTY: Yes.

SLY: What work you do?

KITTY: I'm a teacher.

SLY: Then maybe Kitty can teach Sly some tings? Yeah?

They laugh.

Right now, me lookin' for a new 'oman. Yeah man.
Me need to be loved. Been on me own too long now.

KITTY: Really?

SLY: And you need to hook up with a good man.

KITTY: Really?

SLY: You laughing at me. So pretty when you laugh. Me like to see you happy. Me want to see your smile from morning 'til nighttime.

KITTY: Look, this isn't going to work with me. I'm not looking for…a man.

SLY: But when a man come lookin' for you, maybe you should give 'im a chance.

KITTY: You're far too smooth.

SLY: I cyan help meself. You mek me feel like melted chocolate in a hot muffin. When me see you being massaged back dere, I tink to meself, from the tip of her head to de tip of her toes, dat 'oman is pure sweetness.

KITTY melts.

Come, I tek you for a walk.

KITTY hesitates. She is very tempted. She decides to play it cool.

KITTY: Actually, I'm quite happy here. Still a bit jet-lagged...tired.

SLY: I check you later then.

KITTY settles down. SLY walks away, looking around, constantly on the make.

MAGGIE sits up and grins at KITTY.

MAGGIE: You don't want to let that one go. He's hot.

KITTY: Gonna take it slowly. Window-shop for a bit...you know?

KITTY gets up.

Go and cool down. Nice meeting you.

MAGGIE: See you around.

KITTY smiles and heads towards the sea.

ANTONIO approaches MAGGIE. He tries desperately to be flirtatious.

ANTONIO: You want anything? A drink? Some breakfast?

MAGGIE: I'm going to join my friend – thanks.

ANTONIO: What your room number?

Beat.

Maybe I could come visit you after work?

MAGGIE: What for?

ANTONIO: (*Grins.*) Me want to get to know you – better. You a real nice lady.

MAGGIE stares at ANTONIO for a beat and then laughs out loud. ANTONIO looks hurt.

MAGGIE: That's a good one.

MAGGIE can't stop laughing.

No offence, but… How old are you?

ANTONIO: Eighteen.

MAGGIE: You're a kid.

ANTONIO: Me old enough.

MAGGIE: Old enough for what?

ANTONIO is lost for words. MAGGIE laughs at him. ANTONIO looks humiliated.

Scene 2

It is early evening. REEFIE and YOLANDA are sitting on the beach together. They look happy and relaxed. REEFIE puts his arms around YOLANDA.

REEFIE: Me arms ached for you. It's good to have you back Yolanda.

YOLANDA: It's always good to be back.

REEFIE: You looking good enough to eat.

YOLANDA: There you go again. What is it with you boys out here? One look at me, and you think of food.

REEFIE: Night food.

YOLANDA: Don't be dirty.

REEFIE: One look at you, and we all tink of some loving, some rolling... Reefie love every inch of you. Him miss you. Him dream of you. Him tink on you every day.

They kiss.

YOLANDA: You say the sweetest things.

REEFIE: It for real. You is an empress of womankind. Men should worship on their knees to you.

YOLANDA: Line them up. The more men on their knees to me, the happier I am.

REEFIE grabs YOLANDA's ample breast. YOLANDA screeches and laughs. They kiss again.

REEFIE: We go for a lickle lovin' beneat' de palm trees?

YOLANDA: Didn't you get enough lovin' this afternoon?

REEFIE: Got a lot of time to make up for.

YOLANDA: Later.

They kiss again. REEFIE lays his head on YOLANDA's lap. She strokes his hair.

How's the boat coming on?

REEFIE: Nearly there.

YOLANDA: How big is it?

REEFIE: Twenty feet.

YOLANDA: You ain't gettin' me on any damn boat.

REEFIE: But you love boats.

YOLANDA: Going out on a little glass bottom boat, to the reef is one thing. Least I can see the land. But the big open sea? No way.

REEFIE: Caribbean is calm man.

YOLANDA: Except for when you have those terrible hurricanes.

REEFIE: When you retire, we take a lickle island hopping trip, just we two, 'cross the Caribbean.

YOLANDA: I ain't that old.

REEFIE: You work too hard. Always stress yourself.

YOLANDA: Ain't that the truth. I have to earn a living.

REEFIE: You don't need to earn so much. Come be wid me an' I tek care of you, look after you every day. You don't have to worry your head 'bout nuthin, cos Reefie be there.

YOLANDA: (*Melts.*) Yeah – sounds good to me.

REEFIE: We set out for lickle adventure. Just we two.

YOLANDA: Leave Babylon way behind.

REEFIE: Spend our days in de sun, explorin', swimming.

YOLANDA: No worries.

They kiss again. YOLANDA looks wistfully out to sea. The sun starts to set. A warm pink glow fills the beach.

Ain't that just beautiful?

REEFIE starts to roll a joint.

Reefie, you're not even looking!

REEFIE: Me see it everyday.

YOLANDA: But it's so spectacular. Look how fast it's going down…dipping into the sea…

REEFIE: That's why me cyan leave dis place. Me need to be here. Dem busy cities you live in – make me suffocate.

YOLANDA: Tell me 'bout it.

REEFIE: Need to be surrounded by nature, wid green, wid de eart' between my toes.

YOLANDA: Yeah – I know it.

REEFIE: This where you belong.

YOLANDA smiles happily at REEFIE.

YOLANDA: Twenty foot boat. I don't think you've built it all on my money.

REEFIE lights his joint.

Not that I care.

REEFIE blows smoke into YOLANDA's face.

REEFIE: You have the red eye.

YOLANDA starts to cough.

YOLANDA: What d'you expect? You have to blow that stuff in my face?

REEFIE: No, red eye – mean Yolanda is jealous.

YOLANDA: Bullshit. You smoke too much.

REEFIE: Holy smoke.

YOLANDA: Give me a break.

REEFIE: Give me a line of communication to Jah.

YOLANDA: Makes you completely high.

REEFIE: First step to Jah.

REEFIE passes the joint to YOLANDA. She turns it down.

YOLANDA: Your spliffs blow my mind.

REEFIE: Live a lickle.

YOLANDA: I'll live my life my way, you live it yours.

The sun has set now, darkness starts to descend. YOLANDA slaps at her arms and scratches.

REEFIE: No see-'ems.

YOLANDA: Little shits. Always bite the fuck out of me.

REEFIE: They after your sweet blood. We go back.

REEFIE gets up and helps YOLANDA up.

NAOMI hurries along the beach.

YOLANDA: Hey! Naomi! Hey girl!

NAOMI stops and peers in through the darkness.

NAOMI: Oh, hi Yolanda.

YOLANDA: Reefie, this here's Naomi.

REEFIE: Fiyah, the name's Reefie.

NAOMI: Hi.

YOLANDA: Where you going chile?

NAOMI: Back to the hotel. Apparently there's some live music at Alfred's tonight. Thought I'd get a bite to eat first.

YOLANDA: We're going to Alfred's tonight as well.

REEFIE: Naomi, you walk too fast.

NAOMI: Sorry?

REEFIE: This your first time in Negril?

NAOMI: Erm…yeah…

REEFIE: You gotta learn to take it easy – chill. No problem. You in Jamaica now. What's the hurry?

NAOMI: (*Laughs.*) Oh…yeah…I guess…

REEFIE: Let me show you.

REEFIE walks along the beach, slowly.

REEFIE: See…this be Jamaican style. Let me see you do it.

YOLANDA: Awww…Reefie…c'mon – leave the girl alone.

REEFIE: I teaching her something.

NAOMI hesitates and then copies REEFIE.

Too fast. Try again. Walk the walk. 'Tink Jamaica.

NAOMI tries again.

Look out to sea Naomi…take in a breath of air… slow…slow…yeah mon…that's it.

REEFIE and NAOMI laugh.

YOLANDA: That's exactly how the waiters in my hotel restaurant walk. You yell at them to hurry up and they say 'soon come!'

There is a flash of orange on the horizon.

NAOMI: What's that?

There is another flash of orange.

REEFIE: Lightning.

NAOMI: Amazing.

YOLANDA: It's a long way off.

REEFIE: Me bredren in Cuba is having a storm.

NAOMI: That's Cuba over there?

REEFIE: Yeah mon. Not far. I could get there in my lickle boat in a day. Pay my respects to Fidel.

NAOMI: Cool. Anyway, best be getting back. See you later – yeah?

YOLANDA: You take care now.

NAOMI: Nice meetin' you Reefie.

REEFIE: One love.

NAOMI exits.

She one uptight gyal.

Scene 3

At a live gig on the beach under the stars, with the sound of the waves behind them, loud reggae music is playing. MAGGIE is smoking a joint and dancing wildly on the beach to the music. KITTY is drinking beer and dancing too. REEFIE and YOLANDA are there too. SLY and ANTONIO stand by and watch but their attention is fixed on the two dancing white women.

REEFIE and YOLANDA dance together, like an old married couple.

Eventually, SLY and ANTONIO move in. They dance up close to the women – SLY with KITTY, ANTONIO with MAGGIE. They show up

the women with their superior moves as they dance closer and closer, grinding hips, touching, holding, basically seducing the women.

KITTY and MAGGIE are delighted.

NAOMI sits in the dark on the beach.

ANDRE walks along the beach. He stops when he sees NAOMI sat there.

ANDRE: Hey, you okay?

NAOMI: Yeah…non-stop party here isn't it?

ANDRE: Yeah mon.

NAOMI: Painful to watch them – especially Aunty Mags.

ANDRE looks back.

ANDRE: That who you come with?

NAOMI: My mum's old friend. Terrible dancer.

They laugh.

ANDRE: She havin' a good time. You from England?

NAOMI nods.

My uncle go to live in a place call Bristol. He die there last year. I remember seeing him once when I was a boy. He come back with presents and tings. Bought me a lickle car, the size of my hand. Me love that car. He never come back again. You wan me go? Me botherin' you?

NAOMI: No…no…

ANDRE hovers.

ANDRE: Word is – you born here.

NAOMI: News travels fast.

ANDRE: And you never come back before?

NAOMI: No.

ANDRE: Why?

NAOMI: (*Shrugs.*) Don't have ties here.

ANDRE: You not curious?

NAOMI: Sure… But…didn't know anyone here. Apparently my dad's from here.

ANDRE: Who your daddy?

NAOMI: Never kept in touch.

ANDRE: Sound like a Jamaican man alright.

NAOMI: You're very lucky to live here. It's so beautiful.

ANDRE: In de ole days, used to be turtles here. Certain time of year all o' de eggs hatch on this here beach and we see lickle baby turtles struggling, crawlin' on their bellies to get to sea. Thousands of dem. Our parents tell us not to touch the babies, not to help dem get to the sea 'cos they need to learn to be strong. Very hard to watch when lickle baby turtles get stuck in de sand, cyan move.

NAOMI: Don't the turtles come here anymore?

ANDRE: Tourism, dem frighten. But dem tourist bring in de dollar so now we can all eat.

NAOMI: You're the cook at the hotel?

ANDRE: 'Beach Grill Chef', dat's what dey call me. The food here is pretty basic. I wanna be a proper chef.

NAOMI: Wow.

ANDRE: Need to get some training course but I'll get there eventually. Dis hotel here – de owner say him send me to college after me work here two year.

NAOMI: How long have you worked here then?

ANDRE: Comin' up to the end of my first year. Fish is my speciality – mainly cos my Mam is such a good fish person. Knows everything there is to know.

NAOMI: What's your favourite recipe?

ANDRE: Tiger prawns in coconut. The way I cook it is to fry the prawns separately first – then I make the onions, garlic and ginger into a paste, fry that. Then you put in the prawns, coconut milk and freshly grated coconut – salt, pepper, dash of chilli sauce and let it all simmer together for a bit. Serve it up in coconut shell and a sprinkle of hot red chilli on the top. Eat it up with a nice cold beer. Hmmmm-hmmm.

NAOMI: Delicious…

ANDRE: Fresh lobster with mango and spinach is pretty good too and stuffed jalepeno peppers…that's a speciality of the island.

NAOMI: I really hope you make it. Maybe I'll switch on the telly one day and there you'll be – a celebrity chef!

ANDRE: Me like it. 'Hi, this is Andre Marley live in Paradise, showing you how to make crab soufflé.'

NAOMI: Marley? Is that your surname?

ANDRE: No. But it sound good. And I could grow me some dreads and skank it up while I cook jam.

He sings a chorus of Bob Marley's Jammin'. NAOMI laughs.

NAOMI: You're definitely onto something there.

ANDRE: Why you never come to the island before? Truth now?

NAOMI: I don't know.

ANDRE: You like what you see so far?

NAOMI: Yeah!

ANDRE looks at NAOMI.

What?

ANDRE: Nuttin'.

NAOMI: What?

ANDRE: You differen'.

NAOMI: What, you mean weird?

ANDRE: No, like dem udder touris' gyals.

NAOMI: Yeah?

ANDRE: You look like a good person. But me tink you look like you lose someting.

He stands up.

I gotta get home.

NAOMI is disappointed.

NAOMI: Yeah. Course.

ANDRE: Nice chatting.

NAOMI: Yeah.

ANDRE: Don't sit around here on your own. You get hassled. Dem Jamaican byahs, dem never tek 'no' for an answer.

NAOMI: Don't worry. I'll be fine.

ANDRE walks away. He looks back momentarily, waves and moves on. NAOMI watches him go. Then she gets up and exits.

KITTY and SLY run in. They roll in the sand furiously kissing and hugging, giggling and tugging at each other's clothes. Eventually KITTY pushes SLY away.

KITTY: We should wait.

SLY: (*Kissing her neck.*) What for?

KITTY: Someone might come by and anyway, that ugly security guard's got his eye on us.

SLY looks back.

SLY: Come, we go to your hotel room.

KITTY: Let's just sit here for a minute. It's so romantic.

SLY holds KITTY as they look out onto the dark sea.

SLY: You the prettiest girlfriend I ever have.

KITTY: I don't believe that for a second.

SLY: You mus' believe me.

KITTY: Hey, mind if I take a picture?

SLY: Be my guest.

KITTY produces a camera which she holds up in front of her and SLY. The camera flashes.

SLY: You got a man back home?

KITTY: No…

SLY: I cyan believe it. You so sweet.

KITTY: Lived on my own so long.

SLY: You a strong woman.

KITTY: And lots of men have a problem with that.

SLY: Sly know how to give you some good lovin'.

KITTY: In your strong arms.

KITTY wraps SLY's arms tighter around her.

Hmmm…

They kiss as he rubs her breasts.

SLY: You like a flower in my hand waiting to bloom.

KITTY: You're perfect. Just what the doctor ordered.

They kiss some more.

SLY: Mi been lookin' for a 'oman like you for ever.

KITTY smiles.

Mona Lisa be jealous of your smile.

KITTY: I'm a bit old for you.

SLY: You ageless. But you have wisdom and intelligence.
Me love an intelligent 'oman.

KITTY: Bet you say that to all the girls.

SLY: Me fallin' for you. You're real, you know?

They kiss again.

Scene 4

MAGGIE is sat drinking a bottle of beer on the beach. She looks a little dishevelled and tired. It is morning. She looks out to sea. REEFIE walks past and she raises her bottle to him.

REEFIE: Mornin'.

NAOMI comes down, dressed.

NAOMI: (*Bright.*) Starting early. That your breakfast?

MAGGIE: Haven't been to bed yet.

MAGGIE offers NAOMI a swig of her beer. NAOMI declines but sits down next to MAGGIE.

NAOMI: Have a good time last night?

MAGGIE: Fantastic.

NAOMI: You okay?

MAGGIE: Fine. Enjoying yourself?

NAOMI: Yeah.

MAGGIE: How come you're all dressed up? You going somewhere?

NAOMI: Kingston.

MAGGIE: That's miles away.

NAOMI: Takes about two or three hours. Probably stay the night – come back tomorrow.

MAGGIE: What're you up to?

NAOMI: Bit of sight-seeing that's all.

MAGGIE looks at NAOMI suspiciously.

MAGGIE: I know you better than that Naomi. What's in Kingston?

Beat.

NAOMI: Public records office.

MAGGIE: Shit. Your dad?

NAOMI: I only have his first name registered on my birth certificate – no surname – I figured they might have some kind of official documentation in their central office.

MAGGIE: Why are you doing this?

NAOMI: Curiosity?

MAGGIE: This is exactly why your mother didn't want you to come back here.

NAOMI: She's not here to stop me.

MAGGIE: I wanted you to come back to your roots. I wanted you to see the beauty of the place, be surrounded by your culture, your people.

NAOMI: And you were right. Thank you. But I want to know who my dad was.

MAGGIE: You'll be opening a can of worms.

NAOMI: I should've done this a long time ago.

MAGGIE: So take things easy. One step at a time.

NAOMI: Only here for another ten days. Can't hang around.

MAGGIE: Why d'you want to go looking for trouble?

NAOMI: You think I should just put a lid on it?

MAGGIE: Don't go poking around the dustbins.

NAOMI: You didn't see what mum was like at home.

MAGGIE: She loved you.

NAOMI: She was a bitch.

MAGGIE: Please – don't start…

NAOMI: Told me I ruined her life.

MAGGIE: All mothers say that to their kids.

NAOMI: You said that to yours did you?

MAGGIE: Sometimes. Didn't mean it. Only when I got tired or…look, what's the point of beating her up now? Okay so she wasn't the world's best mum – who is for fuck's sake?

NAOMI: She was ashamed to have a brown-skinned child.

MAGGIE: She adored you.

NAOMI: She denied me any knowledge of my father.

MAGGIE: It's just a fucking name.

NAOMI: It's my fucking name. See you tomorrow.

NAOMI kisses MAGGIE briefly on the cheek and walks away. MAGGIE watches NAOMI go – worried.

MAGGIE: (*Calls out.*) Be careful for fuck's sake! Kingston's a dangerous place!

MAGGIE remains where she is, swigging from her bottle. It's empty. She chucks it into the sea. SLY, ANTONIO and ANDRE enter together. ANTONIO clocks MAGGIE.

SLY: Another plane load flew in today.

ANTONIO: Me see 'em.

ANDRE: Dere's a hen party from Frankfurt.

SLY: Lots of white milk bottles?

ANDRE: (*Laughs.*) Yeah mon.

SLY: The whiter the better. Fill dem up.

ANTONIO: You see Earl is back?

ANDRE: Me see him.

ANTONIO: Say America no good.

SLY: Wha'appened to his milk bottle? She trow 'im out?

ANTONIO: He tell me she no good – get there and she as poor as us. Live in tiny apartment high up in de sky. Bath the same size as our sink.

ANDRE: Me hear from him sister he slap him milk bottle around too much. Neighbours complain, police come around again and again and then him get arrested and deported.

ANTONIO: Shit. He trew it all away.

SLY: Earl a wurtless fool.

ANDRE: He always was dumb. Remember at school? He always brag and lie. Him say fadder was a doctor. Boy, him born a liar.

SLY: – Hey – Andre – on de beach last night you was with a gyal.

ANDRE: I just chat with her.

SLY: Just chat?

ANDRE: She nice.

SLY: 'Nice'? Ooohhh – Andre gettin' soft.

ANTONIO laughs.

You gonna 'fall in love' again?

ANDRE: Shut your mowt'.

SLY laughs.

You always judge everyone by your own low standard Sly.

REEFIE approaches. ANTONIO and SLY both walk over to REEFIE. They treat him with respect. ANDRE is polite but distant with REEFIE.

ANTONIO: New plane load in today.

REEFIE: Yeah Mon.

ANTONIO: Reefie – you gonna fix me up?

ANDRE: Antonio –

REEFIE: Dem ladies all ask after you Andre.

ANDRE: I got me a job.

REEFIE: Show a few ladies around the island and after six month you go to cooking college no problem.

ANDRE: Sebastian say…

REEFIE: …he send you to college? (*Laughs.*) Yeah – right.

SLY: Him a chi chi man.

ANDRE: Me cyan sleep with dem mampi, ugly 'oman.

SLY: Close your eyes and imagine you is with Beyonce.

ANDRE: Me promise Mam never to do dat kinda ting again.

SLY: You do every ting your mam say?

REEFIE, ANTONIO and SLY laugh at ANDRE's expense.

Anyway, what you got dat's so precious – eh? You tink you got yourself some kinda gold tip, red hot poker?

ANDRE: Man respec' himself, den de woman trust him.

SLY: You so clever –

ANDRE: I is not for sale.

SLY looks pissed off.

ANTONIO: So – Reefie? You gonna fix me up with some 'work'?

REEFIE: Maybe

ANTONIO: Me need the money.

REEFIE: What for?

ANTONIO: Washing machine.

SLY, ANDRE and REEFIE laugh.

For me gran. She set her heart on a washing machine. Me see a nice one in town. Five hundred US dollars it cost. All chrome and nice and shiny. Wash a whole week's washing in one go.

REEFIE: Five hundred US dollars?

ANTONIO: It tek me years to buy dat ting wid de money me earn here. Me need to earn some proper cash.

ANDRE: What use your gran hab wid a washing machine when she hab no electrics in her shack?

ANTONIO: Dey bringing the electric to her lane.

ANDRE: When?

ANTONIO: Soon.

SLY: Dem always say soon. But when it happen for real?

ANTONIO: Reefie. Only you can help me.

REEFIE: It depends on the ladies. What they want.

ANTONIO: (*Boasting.*) I had one last night, right here on the beach.

REEFIE: A touris'?

ANTONIO: (*Lies.*) Yup. She rich too. Diamond rings an' dripping with gold chains… She really like me.

ANDRE and SLY don't believe ANTONIO and wind him up.

Me have plenty 'oman before. She was sweet.
Reckon I got me a nice girlfriend.

REEFIE: De higher de monkey climb, de more him parts expose.

ANTONIO: Me not bragging Reefie – me still need your… guidance.

REEFIE: She pay you?

ANTONIO: Yeah. Lot of cyash.

REEFIE: How much?

ANTONIO searches his head for a figure.

ANTONIO: (*Proud.*) Tirty dollars.

SLY laughs at ANTONIO.

REEFIE: Fool. You giving it away.

ANTONIO looks embarrassed. He thought thirty dollars was a lot of money.

You go through me and only me. None of this lone ranger shit.

ANTONIO: You taking me on?

REEFIE: You not even a proper Rasta. You is a wolf. Me see you eating meat.

ANTONIO: The milk bottles dem like Bob Marley.

REEFIE: Where's your respect?

ANTONIO: Me respec' Marley. My ma said she slep' with him once.

SLY: You're Marley's bastard?

ANTONIO: Could be. You see a lickle resemblance?

ANDRE: Him only seventeen. Him born five years after Marley passed on.

SLY and ANDRE crack up.

REEFIE: If I fix you up you get one hundred dollars a night or fifty dollars a fuck. They pay you directly. You gettin' me?

ANTONIO: A hundred dollars?

REEFIE: And you pay me forty percent.

ANTONIO: Massive cut!

REEFIE: Me not cheap.

ANTONIO: How about twenty?

REEFIE: Me say forty.

ANTONIO: Twenty-five?

REEFIE: Tirty-five.

ANTONIO: Tirty.

REEFIE: Okay.

ANTONIO goes to slap palms with REEFIE but he holds back.

One condition. You treat me gyals like ladies.
Anyting me hear 'bout any beatings and me cut you
off. You got me?

ANTONIO: Yeah – course man.

REEFIE: You bust dem up and they don't come back. Dey
don't need to pay good money for that. Still got me
some nice ladies come back every season and why?
Because me treat them good. You gettin' me?

ANTONIO: Cool man.

REEFIE: We better than their white man. They ain't up to
the mark, so when dey come out here and see that we
black boys healthy and look good and ting, dey wan' try
someting new.

ANTONIO: Cool man.

REEFIE: Me only go for de older ones – young pretty gyals
– dey look nice but dey don't have no cash. Dey wan' a
man for free. But de older ones – you show dem a good
time and they'll be generous. Tell dem they got pretty
eyes – it always works.

SLY: Yeah, I use that one.

*ANTONIO and REEFIE slap palms on the deal. ANDRE watches
with disapproval.*

ANDRE: Reefie – how much dey pay you?

REEFIE: Cockroach no business in a fowl yard.

ANDRE: Me jus' curious, is all.

SLY: Reefie part own a glass-bottom boat now.

ANTONIO: Since when?

REEFIE: Last month. The ladies, they like to see the reefs and fish and coral and tings.

ANTONIO: Dat's why dey call you Reefie.

REEFIE: After they see the nature, they all relaxed and happy.

SLY: Den you move in for the kill.

REEFIE: Nature takes its course. You gettin' me?

ANTONIO and SLY laugh.

SLY: Listen to the pro.

REEFIE: (*Suddenly angry.*) What you call me?

SLY: As in pro-fessional. No harm meant. Me givin' you respec' man.

REEFIE: Right.

KITTY comes down onto the beach.

KITTY: Hi there.

SLY: Dere's my sweet lady. Hmmm…mmm…lookin' delicious.

SLY walks up to her, kisses her, holds her hand.

KITTY: You ready?

SLY: I go wherever you take me.

KITTY: We're only going shopping for groceries.

SLY: Me follow you to de end of de eart' sweetness.

KITTY laughs. She and SLY exit, hand in hand. ANTONIO watches jealously.

Scene 5

NAOMI and ANDRE are on a glass-bottom boat out at sea. We can hear the sound of the sea closer now, almost as if they are underwater. They have obviously just been snorkelling. NAOMI stares down at the glass, awe-struck and child like. ANDRE watches her as he takes off his snorkel and flippers.

NAOMI: (*Exhilarated.*) It's a different world down there. So many colours! Did you see that enormous school of fish?

ANDRE: I saw it.

NAOMI: Like they were lit up from inside.

ANDRE: Lickle fairy lights.

NAOMI: Yes!

ANDRE: There's a large bay at Rock, 'bout a mile east of Falmouth – place called Glistening Waters. At night, it glows green when de water move. Fish swimming through it look like green lanterns.

NAOMI: (*Points.*) Look! A turtle!

ANDRE looks.

ANDRE: Hawksbill.

NAOMI: It looks so sweet... Are there sharks round here?

ANDRE: Yeah mon. Nurse sharks. But you not bodder dem, dey not bodder you. Barracudas de ones to watch for.

NAOMI: So many fish.

ANDRE: Seven hundred different species dey say – always zippin' around dese waters. Parrotfish, flounder, blue chromis, goat fish…

ANDRE gazes at NAOMI.

You look like a mermaid.

NAOMI looks pleased but embarrassed.

NAOMI: And you look like a dolphin underwater.

ANDRE: It second nature. Plenty real dolphin here too. Sometime, dey come swim wid you, play games… always look like dey are smiling.

NAOMI: Can't say I've ever seen a depressed looking dolphin.

NAOMI and ANDRE laugh.

Water's so clear down there!

NAOMI points at the water.

What was that?!

ANDRE peers into the glass bottom.

ANDRE: Sea urchin. Dey like hanging round de coral walls. You step on one o' dem, their quill can pierce your skin and break off. Agonising.

NAOMI: You ever been stung by one of those?

ANDRE: No, only jellyfish. Sting bad but hot sand tek away de pain. Me bes' friend at school – Stevie – he stand on

a stingray. It all buried under de sand so he not see it. It slash his leg wid its tail. Full of poison. My fren' he screaming for hours. He nervous of de water since.

NAOMI looks shocked, ANDRE laughs at her.

Caribbean may look calm and beautiful but it hide a lot of tings you have to be careful of.

NAOMI: Thanks for the warning.

ANDRE: I jus' lookin' out for you.

ANDRE reaches forward across the glass-bottom boat, kisses NAOMI tentatively. At first they are both shy and then they linger a little more. ANDRE breaks away.

Me should tek you back to land.

NAOMI looks puzzled.

It gettin' late.

ANDRE stands and starts the motor.

Scene 6

In the light of the full moon we see MAGGIE and ANTONIO have been trying unsuccessfully to have sex. MAGGIE rolls away from underneath ANTONIO. She is pissed off and humiliated.

ANTONIO: Me sorry, dis never happen to me before…

MAGGIE: Forget it.

ANTONIO: Me always…me never hab this trouble.

MAGGIE: (*Annoyed.*) I said forget it.

ANTONIO: It a busy day…me tired…we try again later.

MAGGIE looks bored.

It the sand, it get everywhere.

MAGGIE: Yeah – right.

ANTONIO: It don't mean nuthin'. You is a beautiful 'oman. Me like you, me tink you attractive…

MAGGIE: It doesn't matter.

ANTONIO: Me wan' you but for some reason – my body… I dunno…

MAGGIE: Enough!

ANTONIO: You is pretty…me wan' roll wid you…it's jus…jus…me not know why it not work tonight.

MAGGIE: Stop it.

ANTONIO: Maybe, we can try in your bed. It more comfortable.

MAGGIE: Maybe.

ANTONIO stands up, pulling his trousers up, but MAGGIE pulls them down again.

I wanna play a little game with you.

ANTONIO: You wanna play some more?

MAGGIE: I want you naked.

ANTONIO looks dubious.

No need to be shy. There's only the moon to see us.

ANTONIO strips.

Now stand up against the tree.

ANTONIO does as he is told.

ANTONIO: What you gonna do?

MAGGIE tips a bottle of rum to ANTONIO's lips. He drinks and then she drinks. She stands back and looks at ANTONIO.

MAGGIE: You look good. Such a handsome boy.

MAGGIE fetches a length of rope from behind the trees.

ANTONIO: Where you get dat from?

MAGGIE: Borrowed it from one of the boats.

ANTONIO: What you gonna do wid it?

MAGGIE: Tie you up. If you don't mind.

ANTONIO: Is a game you say?

MAGGIE: Yeah – it'll be fun. Stand still.

MAGGIE ties ANTONIO up to a palm tree with a length of rope.

This way, Antonio, you're all mine, even when you beg for mercy.

ANTONIO: (*Giggles.*) You one mean 'oman.

MAGGIE: And you've been a bad boy, so you need to be punished.

ANTONIO: You not going to hurt me?

MAGGIE: That depends on how well you behave.

ANTONIO: Me cyan move.

MAGGIE: That's the whole point.

ANTONIO: Owww…you pulling the rope too hard.

MAGGIE: Stop complaining.

MAGGIE finishes off tying ANTONIO up and stands back and laughs. ANTONIO looks unnerved.

ANTONIO: What happen now?

MAGGIE bends forward and kisses ANTONIO full on the mouth. He kisses back.

MAGGIE: This is what I love about this place – being one with nature. The moon, the sound of the surf, sand between my toes and a nice young buck. Makes me feel so horny. It's like you've become one with the tree – tall…hardwood.

MAGGIE bursts into fits of giggles. She moves away and hides in the shadows.

ANTONIO: Maggie? MAGGIE? Where you are?

MAGGIE: (*Deep voice.*) I am the voice of your conscience.

ANTONIO: Stop it. You scarin' me now.

MAGGIE: This will teach you to take advantage of innocent tourists.

ANTONIO: Come out where me can see you.

MAGGIE: Taking our money, making us buy you drinks, food, giving you a place to sleep for the night.

ANTONIO: Me jus' love me woman. Nuttin' wrong with that.

MAGGIE emerges from the shadows again. She squeezes her body against ANTONIO's, 'manhandles' him, licks his face.

Me cyan perform like dis. All truss up.

MAGGIE: But it's the way I like it.

ANTONIO: Me cyan hold you.

MAGGIE sits on the beach looking out at the sea. ANTONIO yawns.

That it?

MAGGIE: For now.

ANTONIO: You gonna untie me? Me have to work in de mornin'.

MAGGIE: It's nearly morning already. Let's watch the dawn rise.

MAGGIE looks out to sea wistfully. ANTONIO hangs his head. He is dropping off to sleep.

Back home I get the odd shag every now and then with some loser in my local pub. None of them can perform. By the time the morning comes, can't stand the smell of them in bed. Have to boil the sheets to get rid of the stench. All my dreams slowly melted away. You listening?

ANTONIO's head jerks up.

ANTONIO: Hmmm…

MAGGIE: Don't you dare fall asleep on me. What are your dreams?

ANTONIO: Eh?

MAGGIE: What d'you want to do with your life?

ANTONIO: Work. Mek some proper cyash to tek home.

MAGGIE: On the back of some rich tourist no doubt.

ANTONIO: Me lookin' for love. Me want to work, to have a chance.

MAGGIE: And so the means justifies the ends.

ANTONIO: If me have jus' one lickle chance to prove meself… Me could love you…be your man…

65

MAGGIE: I hardly know you.

ANTONIO: There's no rush. But you could help me as a friend.

MAGGIE: Why should I help you?

ANTONIO: We roll together.

MAGGIE: Get real.

MAGGIE stares out. ANTONIO struggles against his bindings.

ANTONIO: Me uncomfortable now. Please...

MAGGIE: You're all the same. All you blokes. Users – the lot of you. Leeches – sucking our blood, our life, our talents until we're wizened old hags – then you move on.

ANTONIO: You is still a beautiful 'oman. You still have a 'oman's charms, a good body...

MAGGIE: (*Angry.*) No I don't.

ANTONIO: You do!

MAGGIE: Don't lie.

ANTONIO: I not a liad.

MAGGIE: Not really much of a man are you?

ANTONIO: I is a man.

MAGGIE: Can't even get it up for me.

ANTONIO: Me tired, that's all.

MAGGIE: Why d'you do all this pretending? I know you don't find me in the least bit attractive. Maybe you prefer men.

ANTONIO: (*Insulted.*) I is not a batty boy.

MAGGIE: For all I know…

ANTONIO: Hey, hey! Untie me! Untie! You facety to raas gyal!

MAGGIE: (*Taunts.*) Make me – 'batty boy'.

ANTONIO: I is not…

MAGGIE: That's fine if you prefer boys to girls…maybe you should just come to terms with it.

MAGGIE laughs at ANTONIO. He sees red.

ANTONIO: Let me go. Who'd wan' fuck an ugly bitch like you? You a raas blood claat…gorgon…bomba clawt. …old duppy hag!

MAGGIE walks away.

Where you go? Come back! Untie me!

MAGGIE comes back towards ANTONIO. She is carrying the branch of a palm. She attacks ANTONIO with it, lashing out, beating him with ferocity. ANTONIO screams.

Stoppit 'oman. You hurtin' me! Why you doing this! Stoppit! Do, me a beg you! You a fuckin' mad 'oman.

MAGGIE takes some dollars out of her purse and tucks them into the rope bindings.

MAGGIE stares angrily at ANTONIO. Then she exits. ANTONIO remains tied up shouting abuse at her.

Interval

ACT TWO

Scene 1

REEFIE walks across the beach, carrying a machete and some more timber for his boat. He passes ANDRE and ANGEL walking together. ANDRE is carrying ANGEL's bags. They all greet each other. None of them see ANTONIO tied up to the tree behind them. REEFIE walks on.

ANDRE helps to set up, rakes the sand etc.

ANGEL: You 'ave words wid Sebastian?

ANDRE: Not words. Him speak him mind. I speak mine.

ANGEL: But you work one year for him hotel. He mus' pay you more. All o' de other cooks in hotels get pay better.

ANDRE: Me know it Mam. Me look around for a new job but without de training, me cyan get anyting better.

ANGEL is about to unpack her bag when she notices something in the palm trees behind her. She approaches ANTONIO, still tied up and fast asleep. ANDRE follows her.

ANGEL: What a ting!

ANTONIO wakes with a start.

ANTONIO: Angel…Andre…untie me – please.

ANDRE hurriedly unties ANTONIO.

ANDRE: You been like dis all night byah? Who do this to you?

ANTONIO weeps. He collapses on the floor.

ANGEL: Kiss me neck! Look at all dis money. It belong to you?

ANTONIO scrabbles around in the sand, scraping up dollar notes, shoving them in his trouser pockets, weeping like a child all the time.

ANDRE: Cho, Antonio, what kind of folk you gettin' mix up wid?

ANTONIO: Me a beg you, don't tell no one 'bout dis…

ANGEL: Your face all cut up.

ANTONIO: I is fine.

ANGEL: You no look fine to me.

ANTONIO: De gyal ramp wid me. Please. This be our secret. Me no wan' no carry go bring come 'bout 'dis.

ANGEL: Which one of dose touris' women?

ANTONIO: No one…

ANGEL: (*To ANDRE.*) Who?

ANTONIO: Smaddy.

ANDRE: Reefie introduce you to this 'oman?

ANTONIO is silent. ANDRE looks furious.

ANGEL: You mustn't get mix up with dey kind. Dey mess wid' you, abuse you. Dey no good.

ANTONIO: Me need to get me to work.

ANDRE: Antonio, dis not work.

ANGEL: You got no respect? For youself? Your people?

ANTONIO: Me a beg you. Don't chat about me to no one.

ANGEL: Swear to me, you never do dis kinda ting again.

ANDRE: Don't sell yourself.

ANGEL: Don't sell your soul.

ANTONIO: It me body, not my soul. Dat's all dey is interested in.

ANGEL: So why you cry?

ANTONIO tries to stifle his sobs. ANDRE is angry. He cuffs ANTONIO around the face a few times.

ANDRE: Why you cry like a baby? Fool! You tink dis here is a game?

ANGEL pushes ANDRE off ANTONIO.

ANGEL: De body an' soul Antonio – dey steal it. I see it 'appen wid my own man.

ANTONIO runs up the beach. ANGEL watches him go sadly.

ANDRE follows ANTONIO. ANGEL unlocks her small beach hut and rakes the sand out front. She puts up a sign: 'ALOE VERA MASSAGES AND HAIR BRAIDING'.

She stands and looks out to sea. She looks tired.

Scene 2

In KITTY's hotel room, there are unopened bags of shopping strewn around the room. SLY is sat at the table, wearing only his boxer shorts, eating from a tray of room service food. KITTY lies back in the bed, covered only by a sheet, smoking a cigarette watching him eat. SLY eats desperately, like a half-starved man.

KITTY: Jesus, Sly, slow down! (*She laughs.*) You'll get indigestion.

SLY: Me hungry.

KITTY: I can see that.

SLY: (*Between mouthfuls.*) The chef here, he good. Best jerk
 chicken in any of the hotels round here. But me should
 take you to a proper restaurant – 'Sweet Spice'. The
 food there is real – home cooking.

KITTY: You eaten in all the hotels and restaurants round
 here?

SLY: Most o' dem.

KITTY: You've been with a lot of women.

SLY: Cyan help the call of a beautiful 'oman.

KITTY: (*Laughs.*) What are you like?

SLY: Me work in the touris' industry. What you expec'? I
 work as a waiter, a cleaner, a porter, even a captain of a
 glass-bottom boat...

KITTY: Captain Sly. Nice one.

SLY: Best job I have is as a hotel rep. Wear a nice uniform,
 check de guests are okay. Walk around de place,
 chattin', advising – best places to go, fixing up tours
 – dat sort of ting.

KITTY: What happened then?

SLY: New manager, not like the look of me...

KITTY: You remind me of one of my sixth formers. Look
 just like him. Handsome boy – Aaron – doing his 'A'
 levels. All the female teachers have a soft spot for him.

SLY: You roll with him?

KITTY: God no! He's a student, I'm the deputy head teacher.

SLY: But you want to.

KITTY: That would be completely unethical. How old are you by the way?

SLY: How old you tink?

KITTY: Twenty-five?

SLY: No.

KITTY: Twenty-six?

SLY: Down.

KITTY: Younger? Shit. Twenty…three?

SLY shakes his head.

Twenty-two?

SLY nods. KITTY looks horrified.

I would never go out with a twenty-two year old back home.

SLY: Let alone a black man?

KITTY: No! What makes you think that?

SLY: Way you keep going on about my skin – so black – like dark melted chocolate. Like you is doing someting naughty. (*SLY laughs cruelly.*)

KITTY: Oh just hurry up and come back to bed.

SLY: Lickle while. Sly has to have some fuel.

KITTY smiles. She stretches on her bed.

KITTY: God, I wish I could stay like this forever. You wouldn't believe how tough being a teacher is these days.

SLY: Any Jamaicans in your school?

KITTY: Loads. Second and third generation of course. Actually, I'm one of the few members of staff who has a bit of a rapport with them.

SLY: Yeah?

KITTY: I feel comfortable around black people. I like the food, the music – R 'n' B, reggae – I come out here regularly.

SLY: Kitty have a black soul.

KITTY: (*Laughs.*) I guess.

SLY: Black soul trapped in a white body.

SLY laughs, more to himself.

KITTY: You laughing at me?

SLY: No mon. Me know you different. Me feel you understand us. So, Kitty like her job?

KITTY: Couldn't do anything else.

SLY: De pay good?

KITTY: No. Could never afford to live and work in London.

SLY: But you can afford holidays here. Ever marry?

KITTY: Nearly got hitched once.

SLY: No babies?

KITTY: No.

SLY: Your belly don't ache for babies?

KITTY: Never had the time…didn't meet the right man. And way I see it – there are too many kids in the world and not enough responsible parents there to guide them.

SLY: You is right. Pickneys, dem hard work.

KITTY: I have only myself to please. That's what I love about this place. It's so laid back.

SLY: The Jamaican way.

KITTY: Back home, it's rush, rush, rush…

SLY: But you have a good life?

KITTY shrugs.

You ever go hungry?

KITTY: No.

SLY: So, it's a good life. Me always want to see the world.

KITTY: You never left this island?

SLY: In my head – yes. But for real – no. Me hear there are plenty jobs in your country.

KITTY: Plenty shit jobs yeah. But you have to have some qualifications to earn a decent wage. And even then – it's hard.

SLY: Me can go back to school. Study hard. You can be my teacher. I is a good learner.

KITTY: (*Laughs.*) Oh no…

SLY: You like me – yes?

KITTY: You know I do.

SLY: Me can learn to be an English gentleman. You can introduce me to all a your friends.

KITTY: I'm not introducing you to anyone.

SLY: We could trow parties, I teach you tings too like…how to dance, how to cook jerk chicken, how to suck a mango…

KITTY: You really want to come with me to England?

SLY: You could have me all a de time den. When you come back from work – I be dere – waiting for you.

KITTY: My house boy.

SLY: Dere to feast your tired body. You be me mistress. You look after me, I look after you.

KITTY: A prim school teacher by day and a wild uncivilised animal at night!

SLY: We fit like hand in glove. You mek mi nature rise. Way me feel when me grinding inside you – perfec'.

KITTY giggles.

You not feel how good we is together? Me make you hot, me make you wet, me make you moan for more.

KITTY squirms under the sheets in delight.

Me like to hear you moan an' cry for more. An' I can give you more. Much more den you ever dream of. You be my sugar mummy and I be your coochie daddy.

KITTY moans.

Is true what dey say about Jamaican man. We big an' we can work all night for de 'oman we love. We know how to keep 'oman happy.

KITTY: Please stop eating and come back to bed.

SLY smiles and carries on eating.

SLY: Me can order some more on room service?

KITTY: More…? You've eaten…

SLY moves on to the ice cream. It dribbles down his chin.

You eat like a savage.

SLY looks furious.

SLY: Say wa?

KITTY: You heard me.

SLY wipes his face. He is in a rage. KITTY panics. She realises she has said the wrong thing.

Go ahead, order some more food…

SLY: I is not hungry.

SLY is silently fuming and pacing.

KITTY: I'm sorry…it just slipped out… I didn't mean… please… I just got upset. I wanted you back in bed. It was just a stupid word.

KITTY reaches for her purse. She pulls out some dollars. She is desperate.

Look, I went to the bank. I've got some cash. We can have a good time tonight… Nice meal in the evening… Go to 'Jungles' after…

SLY looks at the money. He sits down on the edge of the bed, still fuming, but trying hard to remain calm. He needs this job. KITTY looks relieved. She massages his shoulders.

You said I was the sweetest girl on the beach.

Beat.

SLY: Yeah mon.

KITTY: You said you loved me.

SLY: Me care for you.

Despite his humiliation, SLY remains sitting on the edge of the bed.

Scene 3

Back at ANGEL's hut – YOLANDA is sat on a chair, facing the sea whilst ANGEL braids her hair.

YOLANDA: Reefie's a man of means now.

ANGEL: Him hab plenty money.

YOLANDA: You know he has a house in the mountains?

ANGEL: Him build it with his own bare hands.

YOLANDA: Part owner of a glass-bottom boat.

ANGEL: Hmmm…hmmm…

YOLANDA: And now he's building a boat!

ANGEL: Plannin' his escape.

YOLANDA: What's he runnin' from?

ANGEL: Oh Reefie – him jus' always like building tings.
 You ever go to his house?

YOLANDA: Went there last night. So dark up there at night.
You know he forced me up this ladder onto the roof? I
said to him, 'I ain't going up there. No way you gettin'
my fat arse up that rickety ladder.' He stood underneath
me and pushed my butt up, literally shoved me up there
with his head. I was afraid, that if I slipped and fell, I'd
land on top of him and squish his puny body like a fly.

ANGEL laughs.

ANGEL: Reefie small but him a strong man.

YOLANDA: Must be, cos he got my ass up there. Anyway,
there I am, on top of this fucking roof. I'm so giddy I
start to whine. Felt like a real idiot. Oh, I forget one
small but important detail. I had to close my eyes when
I got to the top. I'm wailing and saying, 'What's the
point Reefie, there ain't no light up here…' Anyway, he
jumps up after me and makes me lay me down on the
roof. My eyes are still closed. I'm thinking, is this crazy
mother gonna screw me up here on the roof?

ANGEL laughs more.

Then he says, 'Open your eyes.' So I open them. I'm
staring up at this sky, studded with stars. I ain't never
seen so many stars. I can't speak, I can't breathe. It's
so dark around me but the stars…oh my…twinkling,
winking, Jesus…it was beautiful. And I lost count of
how many shooting stars I saw. One…two…three…
four… Hundreds of them! I cried all over again.

Can't see the stars in New York – not like that. Then,
there's a breeze and the clouds part, like a misty
curtain and the moon…the full moon emerges. She
looks at me and she smiles. Felt like I could reach
out and touch her. So close!

ANGEL: We see the stars like that every night. Tek it for granted.

YOLANDA: Lay there like that for a couple of hours, sipping rum under the midnight sky.

ANGEL: Cool.

YOLANDA: Took me forever to get down that ladder again. So drunk. 'Course, Reefie don't drink but he was so stoned, he more or less fell back into the house.

ANGEL: He know how to treat a lady – that Reefie.

YOLANDA: Uh-huh…why d'you think I keep coming back for more? But I ain't under any illusions 'bout him. Frank's a good husband…

ANGEL: He know about Reefie?

YOLANDA: No.

ANGEL: Him have another 'oman?

YOLANDA: Frank? (*She laughs.*) All I want out here is some fun. Mind you, I can't be doin' what all them other tourists do. You see them?

ANGEL; Me see dem alright.

YOLANDA: Old women walking down the beach with these young boys.

ANGEL: Dey come 'ere to screw dem sons.

YOLANDA: You said it baby. Pretending they're sex kittens. They reckons black men got bigger… (*YOLANDA points down.*)

ANGEL laughs.

ANGEL: Wish it was true.

YOLANDA: They reckon Jamaican men can keep goin' all night.

ANGEL: Too much ganja for dem to perform.

ANGEL makes a rude gesture with her finger. ANGEL and YOLANDA have a good laugh.

YOLANDA: They say, 'Black men like fucking, black men enjoy the sex act, they don't make love.'

ANGEL: And the beach byahs dem love dat chat. Dem good actor.

YOLANDA: You ever sleep with a white man – Angel?

ANGEL: Many year ago.

YOLANDA: Was he…you know…smaller?

ANGEL: Not dat I remember. But dem byahs, dem tink all dat matta is size. It the loving that count.

YOLANDA: Tell me about it. You hear these ladies on the beach mouthing on, 'He's big, he's like an animal, untamed, primitive, he'd fuck you in the sand and wouldn't think anything the matter with it…' Jesus.

ANGEL: Dem touris', dem buy de fantasy wid hard cyash and tink it real.

YOLANDA: Your boy Andre's doing good.

ANGEL: Yeah mon.

YOLANDA: You met this girl he's been hanging out with? Pretty young English gal?

ANGEL: Me hear but I not meet her.

YOLANDA: How's that man of yours?

ANGEL: Me not see 'im no more. Dat man a Ginnal.

YOLANDA: He work round here?

ANGEL: Him 'work' de beach in Mo Bay. Although, now, it jus' a matter of time.

YOLANDA: Matter of time?

ANGEL: Any day now…

YOLANDA: Shit.

ANGEL: Last time me see him, he a walking duppy. 'Tin, eyes all up in his sockets…walkin' so slowly… No 'oman look at 'im now.

ANGEL trails off.

YOLANDA: God, I'm so sorry.

ANGEL: No matter.

ANGEL looks away, upset.

Me 'ave the test. Me clear. But him…

YOLANDA is quiet.

ANGEL finishes off YOLANDA's hair-braiding and sits down next to YOLANDA for a moment. She looks out to sea. YOLANDA holds her hand and squeezes it. She reaches into her bag and pulls out some dollars which she slips ANGEL.

A little extra. Buy something nice for the kids.

ANGEL: Tanks.

NAOMI walks up the beach. She approaches ANGEL and YOLANDA. She is exhilarated.

NAOMI: Yolanda, nice hair.

YOLANDA: Angel's got damn fast fingers. Best hair braider I ever come across.

ANGEL: (*To NAOMI.*) You should get your hair done. It look pretty on you.

YOLANDA: Oh! Angel – this is Naomi. Naomi – Angel.

ANGEL nods at NAOMI.

NAOMI: Hi – wouldn't mind a massage.

ANGEL: Tirty dollars.

NAOMI: Twenty?

ANGEL: Twenty-five.

NAOMI hesitates.

Twenty-five a good price.

ANGEL produces a mirror from her bag and shows YOLANDA off in it.

YOLANDA: Perfect. Well I'm all done. Gotta be gettin' myself ready for a night out. Thanks again Angel. Be seein' you.

YOLANDA walks away. YOLANDA produces a bench and motions at NAOMI to lie down.

NAOMI: Okay.

NAOMI lies down. ANGEL gets a large aloe vera leaf and starts to massage NAOMI.

Hmmm…that feels good. Ohhh…

ANGEL: This your first time?

NAOMI: In Jamaica?

ANGEL: No, massage.

NAOMI: Oh…no…I've had a few back home.

ANGEL: You is looking for romance?

NAOMI: No! I'm just here…you know…holiday… I'm not like the others who come here looking for a man.

ANGEL: You don't need to. You probably have to fight dem off.

NAOMI: I wish.

ANGEL: No man back home?

NAOMI: No.

ANGEL continues with the massage.

You live round here?

ANGEL: Up in the mountains.

NAOMI: Kids?

ANGEL: Six… And two grandchile.

NAOMI: You don't look old enough.

ANGEL: My fourt' chile – him work hard, here on de beach, in a one of dem restaurant.

NAOMI: What's his name?

ANGEL: Andre – him a grill chef.

NAOMI: You're Andre's mother?

ANGEL: Him bright. Me only worry…him cyan get proper training – in a catering place.

NAOMI: I thought the hotel was going to pay for his training?

ANGEL: Dat manager – Sebastian – him a tight-fisted rass. Him got Andre's arse in a vice. Him say after two years of Andre workin' dere – but me no trust him.

NAOMI: He's a nice man your son. Works very hard.

ANGEL: Yeah mon, me have high hope for 'im.

Beat.

You look mix.

NAOMI: Yeah…I am.

ANGEL: Mudder?

NAOMI: My dad. From here apparently. I was born here.

ANGEL: A Negril baby?

NAOMI: Yep.

ANGEL massages NAOMI's back. They are both in silence for a while.

I never knew my dad. Went to the public records office in Kingston. Maybe you know him?

ANGEL: Jamaica a big island, you tink me know everyone?

NAOMI sits up for a moment and stops the massage. She rummages around in her bag and pulls out some papers. She shows them to ANGEL who glances at them.

This him name here?

NAOMI: Yeah.

ANGEL: Very common name. Sorry. Me know fifty man o' dat name.

NAOMI: My mum was called Julie – everyone called her Jules. She came here on holiday and got pregnant with

me – stayed until I was born. Maybe you remember her?

ANGEL laughs.

ANGEL: Don't be foolish chile! How many white gyal come here and have baby?

NAOMI laughs at herself.

NAOMI: I even got an address of my dad's birthplace.

ANGEL: You been there? You ask around?

NAOMI: Yep – but there're no houses there anymore. Just guest apartments. Talked to the owner – he was an American. Said he didn't know anyone by the name…

NAOMI lies back down again. ANGEL continues with the massage.

ANGEL: He probably move on.

NAOMI: Yeah. Could be anywhere.

ANGEL: Why you want to find your daddy anyway?

NAOMI: Mum died a couple of months ago. Cancer.

ANGEL: Me sorry. You tink your daddy rescue you? Mek you feel whole again? Be dere to look after him lickle baby girl?

NAOMI: No. Just…curious to meet him.

ANGEL: This where your forefathers are from. Jamaica is in your blood. You born here. Fadders come, they go, but the island still floatin' in de Caribbean Sea. Main ting is – you here now. Welcome home Naomi.

NAOMI starts to cry.

Hey...hey...I don't mean to upset you... Sorry mon.

NAOMI: Sorry, sorry...you must think I'm an idiot...

ANGEL: No, mon...no...this place...it touch you...

NAOMI: But this isn't the real Jamaica is it?

ANGEL: Real Jamaica no different from anywhere
else. Everyone suffrin' – lookin' for the next dollar.
Fishermen in Whitehouse Bay, mek more money dese
days hauling nets full of cocaine rather than fish. Dem
yout' earn more selling ganja on de beach than workin'
as a grill chef. You see dem fourteen year old girls up in
Bourbon Beach selling their bodies to old white men?

If you want to see the real Jamaica, find your roots,
dat sort of ting – jus' gwan. Travel around. Go to
the Blue Mountains and Port Antonio. Go to Ocho
and Black River. Drink de islan' up wid your eyes.
Plenty beautiful tings to see here. And good people.
Not everybody after your money. Not everybody
hustlin'.

ANGEL massages NAOMI's shoulders and neck.

Scene 4

MAGGIE, YOLANDA and KITTY are sat out on sundecks sunning themselves. They are all sipping cocktails.

KITTY: This time I have really fallen on my feet. Sly is
gorgeous.

YOLANDA: He go down on you?

KITTY: Not yet. But I'm working on it.

MAGGIE: They don't like doing that out here. Apparently
it's taboo. How about your man?

YOLANDA: Reefie's a Rasta so he's vegetarian.

MAGGIE laughs but KITTY doesn't get it.

MAGGIE: Very good.

KITTY: Eh?

YOLANDA: According to him, he doesn't eat meat so why should he eat that?

KITTY smiles.

KITTY: It's so different out here. Women are worshipped – regardless of size. So…so…

YOLANDA: Liberating.

KITTY: Yes.

YOLANDA: See all them skinny women in their tiny bikinis walking down the beach – they don't even look at them!

KITTY: They only sell extra large condoms at the local shop. And the local women have chicken fat injections in their arses to get bigger. Can you imagine?!

MAGGIE: You know what gets me? Is how effortlessly thin the men all are.

YOLANDA: Probably a lifetime of not getting three square meals a day.

KITTY: It's not poverty. It's the way they're built – part of their nature.

YOLANDA: What you mean the way we're all good at sports, the men all have big dicks and the women make good 'mammys'?

KITTY looks uncomfortable.

KITTY: I'm sorry, I didn't mean to offend you.

YOLANDA: No worries girl. You can't help it. It's part of your nature.

Awkward silence.

So, girls, you got what you came for?

KITTY: Oh yes.

MAGGIE: I've had a few good nights.

KITTY: I've been thinking…well for some time now…of moving out here.

MAGGIE: For good?

KITTY: Jack in the job, use my savings to buy a place out here and set up home with…someone.

YOLANDA: Someone?

KITTY: Buying a nice house in the UK is virtually impossible for me. But here – I could afford to live well.

MAGGIE: What about your friends? Your family?

KITTY: They could come and visit. And besides, they all have their own lives now – families, kids… I'm…well… I fancy a change.

YOLANDA: Honey…

KITTY: I think Sly's the one for me. No more shopping around.

YOLANDA: You only just met him!

KITTY: But it feels so right.

YOLANDA: Sweet Jesus.

MAGGIE: Please, tell me you're joking – right?

KITTY: No. I'm not.

MAGGIE: These boys only want a way off the island.

KITTY: This is different.

YOLANDA: Keep taking the pills.

KITTY: I used to be like you – cynical.

MAGGIE laughs. YOLANDA nearly chokes on her drink.

MAGGIE: No offence Kitty but look at yourself in the mirror. Who are you kidding?

KITTY: I'm only thirty-eight. So what if he's nearly half my age? Age doesn't matter. I can make this work.

MAGGIE: Been all over the world and everywhere I go, it's the same story. The boys only want a passport.

KITTY: Not all of them.

YOLANDA: Need to get to know him better – can't walk away from your life on a whim.

MAGGIE: I know where you're at. It's good to be held tight in a man's arms. Chases away all those lonely nights and stops the questions.

KITTY: No.

MAGGIE: Find yourself asking the same old questions – why am I here on my own? What's wrong with me? If I'm so great – why am I so single?

KITTY: No...no...

MAGGIE: Look. I know the score. I was married. I know how it goes. Staying with a man is about settling for second best. It's an economic contract.

KITTY: Wish I'd settled down. Always too busy with my career.

MAGGIE: Yeah, but marriage is a compromise.

YOLANDA: I have a very good marriage.

MAGGIE: So why are you here?

YOLANDA looks away, irritated.

MAGGIE: Some women can cope with boredom. You have kids, you nurture them, teach them, love them, they grow up and leave you. And then your man leaves you too.

KITTY: Is that what happened to you? Your husband left you?

MAGGIE: (*Ignoring the question.*) Women are strong. We can exist quite happily on our own. But then there comes a point in a woman's life where she aches to be touched, desired... Real love? It never lasts.

KITTY: (*Angry.*) I think that's just horrible.

MAGGIE: All I'm saying is wake up before you get hurt.

KITTY: It's different between me and Sly. It's real.

YOLANDA: How can it be honey?

KITTY: Fuck off! Love conquers all.

MAGGIE bursts into laughter. KITTY walks away, upset.

YOLANDA: D'you think we were too hard on her?

MAGGIE: Truth always hurts.

YOLANDA: Yeah. Two weeks and she wants to settle down? She's heading for a fall, ain't that the truth?

MAGGIE and YOLANDA slap palms and laugh.

REEFIE enters, kisses YOLANDA briefly and squeezes next to her on the sunbed. They rub noses and do a little canoodling. MAGGIE watches on – a little envious. ANGEL walks by. She waits quietly but says nothing. REEFIE looks up.

REEFIE: Hey, Angel.

ANGEL: Can me have a word?

REEFIE: Sure ting.

ANGEL walks away. REEFIE gets the hint. He gets up and follows her. ANGEL and REEFIE stand to one side.

Everyting cool Angel?

ANGEL: That mix gyal. Naomi?

REEFIE looks none the wiser.

She staying here at the hotel. Young, pretty gyal. From Englan'.

REEFIE: Oh – yeah mon – me know her.

ANGEL: She lookin' for her daddy.

REEFIE: Me hear.

ANGEL: She twenty-eight. Her English mam call Jules and Naomi, she born here.

REEFIE doesn't flinch.

She have a name. She have your name. Me tink you should know.

ANGEL turns and leaves. REEFIE is stunned.

Scene 5

ANDRE and NAOMI are sat by the sea together.

ANDRE: You come back soon?

NAOMI: I'm not going yet. Thought I'd extend my holiday and see the island. Roaring river…Blue Mountains… Auntie Mags has to get back.

ANDRE: When you leave?

NAOMI: Tomorrow. I'll miss you.

ANDRE is moved. He reaches out and touches NAOMI's face. She enjoys his touch but then he pulls away.

Andre. I wanted to do something for you.

ANDRE looks wary.

ANDRE: Why?

NAOMI: Why not?

ANDRE: Me not want your money.

NAOMI: What?

ANDRE: Me like you, you mek me feel good, but me not want your cash.

NAOMI: I know.

ANDRE: I see it too much round here. Friendships dey call dem. But you cyan have a friendship based on cash. It not balance.

NAOMI: But friends do help each other.

ANDRE looks very uneasy.

I know you want to go to catering school – your mum was saying…and I was talking to one of the chefs up at the Grand Lido. He said that there's a good catering school in Kingston. It's a year's diploma course – you learn all sorts of chef skills and you get a certificate at the end of it. Apparently, it's hard work, full time and it costs.

ANDRE: Me know de school.

NAOMI: I could pay for you to go there – for a year. I could support you – as a friend.

ANDRE looks angry.

ANDRE: Why you do dis? Me look like a charity case to you?

NAOMI: No.

ANDRE: You see me in de same two shirts every day and you feel sorry for me – is dat it?

NAOMI: No.

ANDRE: So why you have to spoil our friendship?

NAOMI: You've taken this the wrong way…

ANDRE: Me not my fadder's son.

NAOMI: I never said you were.

ANDRE: You you wan' someting in return?

NAOMI: I'm offering you help. If you're too fucked up to accept it – fine.

ANDRE: I is not fucked up.

NAOMI: Then why can't you see my offer for what it is?

ANDRE: You cyan buy a lickle piece of me. I is not for sale.

NAOMI: Okay. I offered. You declined. End of story. Let's not get all worked up about it. I'm sorry if I offended you.

The two look out to sea.

ANDRE: What you do tonight?

NAOMI: Pack.

ANDRE: Me see you den.

ANDRE gets up to go. NAOMI looks at him, upset.

NAOMI: That's it?

ANDRE: What you wan' me to say?

NAOMI: Wish me luck with my trip? Goodbye? Whatever.

ANDRE: Me wish you luck. Me hope you find what you is lookin' for.

ANDRE exits. NAOMI is crestfallen.

Scene 6

It is later. ANTONIO is sat on the beach looking out to sea. SLY enters.

SLY: So, where your girlfriend Antonio?

ANTONIO: Where yours?

SLY: Mekin' herself pretty for me. We going down to Roots Bamboo tonight. She fly back tomorrow.

ANTONIO: They have a good band down dere tonight?

SLY: So me hear.

ANTONIO: You see Reefie 'round?

SLY: No man.

ANTONIO: Him say him give me work but so far...I only get one crazy 'oman...

SLY: Jus' try a lickle patience man. Reefie see you arright.

ANDRE enters, looking upset and wound up.

Andre – how's your gyal?

ANDRE does not reply.

She's so fine that Naomi... She hab money?

ANDRE: Me not after her money.

ANTONIO: So you is after her?

SLY: But he is superior to all of us because he wind himself round her heart first, for free, den he move in for de kill.

ANDRE: Me not gravalishus like you.

SLY: Talk nice to her, mek her feel it's for real or it ain't gonna last.

ANDRE: Why you always mek fun?

ANTONIO and SLY have a good laugh at ANDRE's expense.

SLY: It not funny Andre – it sad. You is lyin' to yourself.

ANDRE: Only liar I see is the one facin' me.

SLY stands up and faces ANDRE but REEFIE enters. He looks downcast, a little troubled. He beckons ANTONIO over. ANTONIO approaches.

REEFIE: Me have a girlfriend for you.

ANTONIO: For me? Really?

REEFIE: Sure ting. She comin' down to the bar. She want you to show her a good time.

ANTONIO: Tanks Reefie.

ANDRE: Antonio – don't…

REEFIE pushes ANDRE aside.

REEFIE: You keep outa dis. I is warning you.

ANDRE stands to one side and silently fumes. REEFIE goes back to ANTONIO.

German lady. Name of Anna.

REEFIE pulls out some money from his pocket.

She pay me arredy.

REEFIE counts out seventy dollars and hands it over to ANTONIO. ANTONIO can't believe his luck.

I tek my cut. This is yours. Seventy dollars. Check it. Me no wanna hear no accusations flying later.

ANTONIO counts the money out and kisses it.

ANTONIO: She pretty?

REEFIE gives ANTONIO a look.

No matter. Me no care. Tonight Anna is de most beautiful ting on dis island.

REEFIE: What else you gonna tell her?

ANTONIO: That she has hair de colour of gold spun in the sun.

REEFIE: She hab black hair.

SLY laughs. ANDRE looks pissed off.

ANTONIO: Oh – den – she hab hair de colour of night, wid de moon glistening and shimmering in her locks....

SLY: Yeah mon.

ANTONIO: And when de stars come out...

ANDRE: Her fangs come out.

SLY cracks up. ANTONIO ignores them both.

ANTONIO: ...When de stars come out dey weep to see her eyes, twinkling, dat hide their beauty.

SLY: He rappin now...

ANTONIO and SLY slap palms. ANDRE looks unimpressed.

ANTONIO: How long I got?

REEFIE: Half-hour.

ANTONIO: Me take a shower.

SLY: And change your shirt man.

REEFIE: Some tips Antonio. Never look at your watch. You have all de time in de world.

ANTONIO: Got it.

REEFIE: Always you look in her eyes.

ANTONIO: Sure ting.

SLY: Be cool. Don't go too far wid de compliments. Den dey suspec' you fakin' it.

REEFIE: Mek her feel like she de only 'oman for you. Den, maybe she call you back.

SLY: Or tek you to Germany!

ANTONIO: Tanks Reefie. You a good man. How me know who she is?

REEFIE: She know you. She see you on de beach. She find you in de bar. An' one more ting Antonio.

ANTONIO: Yeah mon?

REEFIE: Don't let her tie you up naked to a tree and whip your arse. No need to be dat cheap.

ANTONIO looks embarrassed.

ANTONIO: Awww…Reefie…how you hear 'bout dat?

He looks accusingly across at ANDRE.

REEFIE: Everybody know.

ANTONIO hangs his head.

Me on de case. No one treat my boys like dat.

ANTONIO: Don't do nothing. She a fucked up old lady.

REEFIE: She Naomi's friend – Maggie – right?

ANTONIO is silent.

Right?

ANTONIO nods.

SLY: We should mash her up.

ANDRE: No…

REEFIE: Jus' a lickle revenge.

SLY: Tie her to a tree and whop her arse.

REEFIE: Me slip a little someting in her drink tonight.

ANDRE: No man – don't be doin' that…

SLY: She deserve it.

REEFIE: Nuttin' heavy. A lickle laxative.

SLY: Bring on de shits.

REEFIE: And I set her up with Mad Eye for tonight.

SLY: (*Cracks up.*) Mad eye? Oh man. Him hab real personal hygiene problem.

ANTONIO touches fists with REEFIE.

ANTONIO: Tanks Reefie.

REEFIE: We look out for our own. Got it?

ANTONIO nods.

ANDRE: You don't need to do dis ting Antonio. You young. You can work and keep your self-respec'.

ANTONIO turns and looks at ANDRE

ANDRE: Please. Tink careful.

ANTONIO: It for my gran. She old. She deserve some rest.

ANTONIO exits excitedly.

SLY: (*Calls out.*) Skank it up!

ANDRE looks at REEFIE and turns away, angry.

ANDRE: You turn little Antonio into a whore.

REEFIE: I give him what he want.

ANDRE: It not right. One day, I'm gonna get out of this place.

SLY: Yeah – right.

ANDRE: You watch me Sly.

SLY: You always had your head up in the clouds.

ANDRE: I got me ambition.

SLY: Ambition is one thing. Stupidness is another.

ANDRE: Shut your mowt'.

SLY: (*Laughs.*) You always tink you is better than us.

ANDRE: No. Me tink me can do better if me put my mind to it.

SLY: In a shack with no water. Ghetto chef cooking in the gutter.

REEFIE: Me hear about you mekin' de moves on Naomi.

ANDRE is silent.

You tink a nice gyal like dat would have anyting to do wid a wurtless grill boy? A kitchen hand?

ANDRE: You wicked Reefie. You bring everyone down to your level. Me different. Me not like you.

SLY: Blood claat.

REEFIE: You no better dan your fadder. He sell himself for a plate of food.

ANDRE: I is not like my fadder.

REEFIE: You can pretend but you have his blood.

ANDRE: But I not de one whorin' for a livin'.

SLY (*To ANDRE.*) Look in de mirror before you chat shit. You the same as the rest of us.

ANDRE: When I look in de mirror, I see me. I know who I is. What you see? Gigolos? Whores? Lyin to dese harpy 'oman – pretending you like dem. How you do

it? It make my flesh crawl to see you at 'work'. Rubbing oil into dem fat, white whales, playing de obedient loverman. Always pretending.

REEFIE: Don't disrespect me or my ladies.

ANDRE: You believe all a dat shit you chat? Me know you. Me know you is nuttin' more dan a rascal. You lie to eat. You hate dem ladies. You hab no respect for nobody – not even youself.

REEFIE: Me hab plenty respec'.

ANDRE: You is false, you is a fake.

REEFIE: Stop! Your mudder my frien'.

ANDRE: You no frien' to my mudder. You de one who mek me sell dem ganja to dem touris. I is eighteen den. You not stand by me when I get arrested. You no even put up me bail. I never tell me Mam it you who set me up. If she know de trut' about you, she spit on you. She step over your dead body in de street, she kick you rass arse.

REEFIE: Enough!

ANDRE: You is a devil hiding behind your dreads. A wolf.

REEFIE: If I is a wolf, why my ladies come back for more?

ANDRE: Because they is sad and lonely and you is nuttin' more dan a renta dread and a dirty pimp.

There is a hush as SLY looks anxious.

SLY: Tink 'pon what you say Andre!

ANDRE: Him know me right.

REEFIE: And who give me my firs' job? Eh? Your good for nutten, rass claat, renk dread – daddy. Least I makin'

someting of my life, what he doin'? Eh? Rottin' in some shack. Dress in rags I hear. Starvin', beggin', nobody wan' know him.

ANDRE is furious. He lunges at REEFIE. REEFIE tries to back off.

Don't mek me do it.

ANDRE: Do what old man?

REEFIE: Me not wan' hurt you.

ANDRE: You a toothless lion.

REEFIE: Don't vex me.

ANDRE: You not even a man anymore.

ANDRE punches REEFIE hard. REEFIE reels and then hits back. They start to fight viciously.

REEFIE: You say that again and I'll cut you up so bad, your mudder won't know you!

ANDRE: Think you so big?

REEFIE: Me a come wid me mashait!

REEFIE grabs his machete and brandishes it menacingly at ANDRE. ANDRE eggs him on.

ANDRE: Come, come! I show you how to fight like a man. Den when me kill you, I fuck your mudder, I fuck your woman and den after dat I fuck your dawta.

YOLANDA and ANGEL enter. They see the men fighting and wade in.

YOLANDA: No! Stop it! No!

YOLANDA tries to pull REEFIE off ANDRE – to no avail.

REEFIE: Yolanda – stay away from dis.

ANGEL: You tek your hand off me byah right now Reefie.

REEFIE: Your byah need to learn him lesson.

ANGEL: Leave him – please!

YOLANDA: (*Starts to shout.*) Stop it! I mean it! If you don't quit this I'm callin' the police. Don't think I won't!

SLY manages to hold ANDRE back.

Will the two of you grow up? I don't know what the fuck you're playing at Reefie, but this has got to stop right now.

REEFIE looks down.

ANGEL grabs ANDRE and pushes him away. ANDRE glowers at REEFIE, as ANGEL frog-marches him out.

YOLANDA, REEFIE and SLY are left together. SLY looks a bit shaken.

Scene 7

ANDRE is pacing on the beach by ANGEL's massage hut.

ANGEL: Why you fight? Why?

ANDRE: Me have nuthin' to say to you.

ANGEL: I not recognise my own son. Wha'appen?

ANDRE: Nuthin'.

ANGEL: It not look like nuthin' to me.

ANDRE is silent.

This not like you Andre. Look at me.

ANDRE refuses to look.

Look at me!

ANDRE faces ANGEL.

ANDRE: Him call me wurtless...him tell me I not good enough for Naomi.

ANGEL: (*Realising.*) Dis about her?

ANDRE: Why you old folk cyan keep your noses outa my business? Why you all gotta make trouble?

ANGEL: What trouble I mek?

ANDRE: What it to Reefie if me mek friend with Naomi?

ANGEL looks disturbed.

ANDRE: You all a de same. You, my fadder, Reefie...

ANGEL: How you say that?

ANDRE: How you any differen'? You my mam, you tell me to have self respec'. Me listen to you. Me try to do the right thing...

ANGEL: Me know. You a good bwoy. Why you so vex wid me?

ANDRE: You speak to her.

ANGEL: Who her?

ANDRE: Naomi! You tell her me need money for school. She offer me money like me is like all o' dem others.

ANGEL realises.

ANGEL: Me only mention...

ANDRE: On purpose. She insult me.

ANGEL: She a nice girl. She like you.

ANDRE: Me no wan' her money. Me not a lickle slave boy who need education.

ANGEL: Hush yourself now. You overreacting.

ANDRE: Me meet a girl. Me like her. Me tink, if there a chance of maybe…and then you walk in dere and poison it.

ANGEL: No …

ANDRE: You prostitute me, Reefie wan' sell me too. And now Naomi, she wan' buy me. How you do this to me mam?

ANGEL sits down.

ANGEL: Me no wan' nuthin' but happiness for you.

ANDRE: So how come I not happy?

ANGEL: You need to get off dis island.

ANDRE: You wan' me to go?

ANGEL: No. But there no future for you here. Only way forward is off dis island. It cursed. For people like us – no money, no school, we cyan' afford to live.

ANDRE: That not true.

ANGEL: You tink I don't want the best for you? My son? Look at your oldes' brudder in Kingston. He work so hard. Him clever but him never have enough. Him can barely afford to send him dawtas to school. Me live in tin shack, no runnin' water, no car. When it change? It always the same. You go to school, you have a chance. You cyan work anywhere in de world.

ANDRE: I work my way through to college.

ANGEL: How?

ANDRE: Someting will happen.

ANGEL: Your fadder wait for someting to happen and it never happen. Him try for years. Him work in sugar fields in Florida, in bar, in kitchen, in hotel. Him never manage. You have a chance to escape.

ANDRE: And how dat mek me differen' from my fadder?

ANGEL: She offer help.

ANDRE: You set me up Mam.

ANGEL: No. I try and push you in the right direction. Naomi nice. She not some fat old woman. She lost. She searchin' for somebody to love. And me know you feel someting for her.

ANDRE: Me only know her two week.

ANGEL: Me no wanna lose you. You my precious chile but me no want to see you sink. Sometime, you have to grab your chances.

ANDRE: Mam, I don't get you. You full of…

ANGEL: You special Andre. You set an example for your lickle brother an' he will follow you. You have ambition and you can have everyting.

ANDRE: Me jus' wan' work Mam. Good work – not dis grilling lobster and cooking jerk chicken day an' night.

ANGEL: So go and study more! She pay for it – what of it? Me wan' sit and eat in my bwoy's restaurant one day. Me wan' to see you with your own place.

ANDRE: (*Grins.*) Yeah mon. Likkle place up dere on de cliffs. Tables with fancy light and lot of chef runnin' around de kitchen.

ANDRE is calmer now. He sits at his mother's feet.

ANGEL: Me hear life in Englan' is hard and it a cold country. But there are plenty Jamaicans there.

ANDRE: Me no wanna leave here Mam. This my home.

Scene 8

YOLANDA is pacing while REEFIE sits with his back to her.

YOLANDA: This place – always violence bubbling away under the surface.

REEFIE: We have a violent history.

YOLANDA: That's no fucking excuse. What was that all about?

REEFIE remains silent.

My last night as well. Thanks Reefie.

YOLANDA walks a little distance away and sits down. She sits and looks out to sea. They remain in silence for a while.

REEFIE: Seem like you only jus' arrive.

YOLANDA: Looks like I'm leaving in the nick of time – just as you turn nasty.

REEFIE: Him start it.

YOLANDA: Listen to yourself.

REEFIE: Me want grow old with you.

YOLANDA: Not sure what my husband Frank would say to that.

REEFIE: Frank know about me?

Beat.

Him know?

YOLANDA: Yeah.

REEFIE: You tell him?

YOLANDA: We had words. It got heated. He found your texts on my cellphone.

REEFIE: Rass.

YOLANDA: He never let on 'til I was leaving for the airport.

REEFIE: You love him?

YOLANDA: He's the father of my kids. We've been together since we were virtually kids.

REEFIE: And me?

YOLANDA looks away.

Jus' a lickle holiday romance?

YOLANDA: Five years Reefie. I've come back to you five years on the trot. What does that say to you? I know what you do for a living.

REEFIE: You different. Me give it all up for you.

YOLANDA: Pardon me if I don't believe you.

REEFIE: Five years and you still tink me a liad? Admit you love me.

YOLANDA: 'Course I love you. I just don't trust you.

REEFIE: Then come and be with me.

YOLANDA: I can't.

REEFIE: You break my heart every time you go.

YOLANDA: I can't leave Frank. Not even for you. There are some things you just don't do.

Beat.

You spoken to Naomi yet?

REEFIE: Me not her fadder.

YOLANDA: That why you've been hanging around the hotel gazing longingly at her?

REEFIE: Me gazing longingly at you, not her.

YOLANDA: You know her mother died.

REEFIE looks upset but covers up.

If she's your daughter...as Angel says she is...

REEFIE: That woman talk too much.

YOLANDA: What are you afraid of? She ain't gonna reject you – she wants to meet you.

REEFIE: Dis is none of your business.

YOLANDA: I know it but that doesn't stop me from...

REEFIE: Enough!

YOLANDA: Explain it to me Reefie cos I sure as hell can't figure it out. I know you have kids on this island – several – from what you said and I also happen to

know that they don't want nothin' to do with you cos you were never there for them.

REEFIE: Me let them free.

YOLANDA: More like they rejected you. And now here's this gorgeous long lost child with the same blood flowing through her veins as you, travels thousands of miles to search you out and you can't even be bothered to wave your hand at her?

REEFIE: I said enough!

YOLANDA looks out to sea and sighs.

YOLANDA: You don't like to hold on to people do you?

REEFIE: Dem always slip from me hand. But me care for you Yolanda.

YOLANDA: Keep comin' back for you Reefie but we ain't going no place are we? So what's the point? This is my last visit Reefie. I ain't comin' back.

YOLANDA gets up and walks away. REEFIE sits on his own.

Scene 9

ANDRE and NAOMI are together again. NAOMI looks at ANDRE's cut eye.

NAOMI: Nasty cut. D'you get into a lot of fights?

ANDRE: No. Me usually avoid dem. Dis one I walk into eyes open. Idiot dat I am.

NAOMI: Andre – I know you're angry with me…your mum but she only wants what's best for you. I like your mum.

ANDRE: She always stand by me.

NAOMI: And I stand by my offer to help you. After the course, you could get yourself a good job in time. You could get paid well – you'd have a future – if you did well you might even be able to travel. You have a skill and you need to develop it.

ANDRE is torn.

I don't want you to feel beholden to me in any way. The offer comes from me. I earn enough to support you for a year. I inherited a little from my mother… and I work…and I like you. I like your spirit and I want to help.

ANDRE: You like my spirit?

NAOMI: Everything I say seems to piss you off! I'm trying to… I want to…

ANDRE: Me wan' to go to catering school. Me need the training but…if me tek your money, it a deal – I pay you back. When me mek my money as a proper chef, me pay you back – however long it take – even if it tek forever.

NAOMI: Okay.

ANDRE looks at NAOMI.

ANDRE: A gentleman's word.

NAOMI: Okay.

ANDRE: On my honour.

NAOMI: Okay!

They shake hands.

It's a deal.

ANDRE: Good. Only one ting complicate it all.

NAOMI: What?

ANDRE: How me feel. Me like you more dan a friend. So where dat leave me and you?

NAOMI: I don't know – depends on where you want to take it…

ANDRE: Two week – too short a time to get to know you. But…

ANDRE moves forward and kisses NAOMI.

Me wan' get to know you better.

NAOMI: I'd like that.

They kiss again.

Just so you know – I'm different – from all these women out here.

ANDRE: And I is different from all o' dese island men.

They kiss again, more passionately. They part again, guiltily – both looking out to sea, unsure of what to do next.

NAOMI: Would you…would you like to…maybe…?

ANDRE: We can go to your hotel room?

NAOMI nods nervously. ANDRE kisses her again. They get up, hold hands and exit together.

Scene 10

We are in KITTY's hotel room. Her bag is packed and ready. She is all dressed up to go out with SLY and is putting on the finishing touches to her face. SLY enters.

KITTY: Hi there.

SLY: You areddi?

KITTY turns and smiles at SLY.

Pretty dress.

KITTY: Thank you.

SLY: Me gonna have to be your bodyguard tonight.

KITTY and SLY embrace.

All dem guys gonna want to chat wid you.

KITTY: I'll stick like glue to you.

They kiss.

Last night.

SLY: Me gonna miss my Kitty Kat. No one to cling to at night. Me miss you already. What time your flight tomorrow?

KITTY: Not until the evening.

SLY looks at the suitcase

SLY: You already pack?

KITTY: There's a couple of things I've planned to do in the morning. Can you stick around in the morning?

SLY: Cool mon. And you mus' give me your cellphone number.

KITTY: You going to call me? All the way in England?

SLY: You not want keep in touch?

KITTY: 'Course I do. I'll be phoning you every day.

KITTY hugs SLY again.

SLY: Sure ting. And you come back...soon?

KITTY: You mean that?

SLY: Yeah mon. I cyan wait for you.

KITTY: What if I came back soon.

SLY: Eh?

KITTY: Come, sit with me. I want to tell you something.

SLY sits with KITTY on her bed. She wraps her arms around him while she talks.

I was thinking of going to see some properties on the way out to the airport tomorrow. I want you to come with me. Have a look...give me some advice.

SLY: You wanna buy some place? Like a holiday home?

KITTY: A holiday home to start with but then...

SLY: Den what?

KITTY: A home.

SLY: You wan' live here?

KITTY: I feel like I've finally found the island of my soul.

SLY looks confused.

SLY: But you have a job.

KITTY: Don't want to work like a dog all my life. Got some savings...could move out here.

SLY: Cool mon.

KITTY: You think that would be a good idea?

SLY hesitates.

SLY: If you like it here – sure mon.

KITTY: And us…

SLY: I see you more.

KITTY: Yes but…it could be your home too.

SLY stares at KITTY.

I know it's a bit sudden Sly but, I don't want it to
end. I don't want us to end. I'm not getting any
younger and I figured, we're good together…we
should just make a go of it.

SLY: You give up your house? Your country? Your job? For
me?

KITTY: For our future. Come back in say three months
time. It'll take me that long to sort out my shit back
home. Will you wait for me?

SLY: Sure ting.

KITTY: You think I'm mad?

SLY: No…is just sudden….two weeks…is quick man.

KITTY: But it just happened didn't it? I've had other
boyfriends but I've never felt like this…. (*She giggles.*) I
want to wake up next to you every morning.

SLY: You hab money to survive out here? Without a job?

KITTY: For a while. Then I'm sure I could get a job
– teaching even.

SLY: Yes. But you cyan survive on what de schools pay
teachers here and I cyan look after you…

KITTY pulls out her purse and hands over some dollars to SLY.

KITTY: I can give you some money to tide you over.

SLY turns the money down.

We're so good together. I feel so happy with you...I love you...

SLY: Me love you too but...

KITTY: I can even wire you money if you need me to.

SLY: Kitty...

KITTY: I want us to have a family.

SLY looks at KITTY incredulous.

I want to have babies. I want to have your babies.

SLY stands up and paces.

I'm older than you, I know. But that's why I can see things clearer than you. Experience I guess. We're good for each other. I could help you. Put you through school or college. You could get a good job – maybe even in the hotel industry – whatever you want. I could help you.

SLY: Listen to me Kitty. Me like you, me care for you, but all o' dis too fast for me. You got to slow down gyal.

KITTY: I've thought about it.

SLY: You say you don't wan' kids.

KITTY: I lied.

SLY: Me have other tings in my life. Is complicated.

KITTY: Oh right, so I give up everything for you but you can't do the same for me. That's not fair is it?

SLY: Rass man! I ask you to give up everyting for me? I ask you?

KITTY looks at SLY's angry face and relents.

KITTY: No – okay. It's too fast. I'm sorry. You're right.

SLY: Tink about what you sayin' Kitty. We not know each other well enough.

KITTY: What more is there to know? If a thing feels right.

SLY: But it have to go two way 'oman. Me have to feel de same.

KITTY: And you don't?

Beat.

SLY: Is too soon to chat 'bout family. Too early.

SLY looks sorry for KITTY but moves towards the door. He looks back at KITTY.

Me sorry Kitty.

KITTY: Don't go!

SLY looks uncomfortable.

SLY: Me cyan give you what you want.

KITTY: Doesn't matter. So I jumped the gun a bit. Time of life. Forget it. We can go back to the way things were. No strings – that how you like it?

SLY: You leavin' tomorrow…we hab us some good times but…

KITTY: I'll be back and we can take up again. Who knows where it might lead?

SLY: Kitty. Me already have a 'oman and tree pickney. Me 'ave to work to feed dem.

KITTY looks up at SLY in fury.

KITTY: What did you say?

SLY: You hear me.

KITTY: But you're only twenty-two! How can you have three kids?

SLY: I is not twenty-two. I is tirty-five.

KITTY: But you said...

SLY: I said what I said cos that what you want to hear. You want a young man. Someone who remind you of dat nice schoolboy o' yours. I be whoever you want me to be. But it not me. It not real.

KITTY: (*Furious.*) You evil, evil bastard. You fucking liar... fucking two-faced fucking shit. You led me on.

SLY: How is dat?

KITTY: You lied.

SLY: I give you what you want. You pay me. Dat how it work. Me tink you know.

KITTY: Was this all a game for you?

SLY: No, it work. Life on dis island not a game. Me have to feed me kin.

KITTY: I thought you felt something for me?

SLY: Me feel someting for you?

KITTY: You bastard. Motherfucking pile of shit.

KITTY lunges at SLY, slapping and kicking. SLY laughs holding onto KITTY's flailing arms.

SLY: For someone who is so educated, you is remarkable stupid.

KITTY: Lowlife scum. You people can't be helped.

SLY: Is that so?

KITTY: Just like all those good-for-nothing students of mine. You think the world owes you whilst you just take, take, take…

SLY: You is not fit to be a mother. Me hope you stay barren.

KITTY kicks and screams. SLY holds onto tight to KITTY's arms and avoids the kicks.

KITTY: You worthless piece of filth. I hate you! You'll live and die in poverty, never able to provide for your miserable kids. Boy, did you miss your chance. I could've lifted you from your shit life. I hope you rot on this stinking island.

SLY: Me should be so grateful?

KITTY: You'll regret this! You will. You'll look back and wish you'd treated me better – with respect!

SLY: And how am I suppose to respec' a gyal like you? You tink me a savage, a house slave. You look at me and you is jealous of my skin, but glad you is white. You tink you is superior.

KITTY: I am superior because you're nothing more than a prostitute.

SLY: And you is jus' a client. You hab to pay for each lickle second me spend wid you. Every lickle compliment costs. One cent for every step me tek wid you, every footprint in de sand. One dollar for me to say you is lookin' good; five dollars for me to hold you tight; ten dollars when me say me care for you. You pay for every kiss, every whisper, every stroke, every fuck. How empty your life mus' be Kitty when you hab to pay smaddy to say a lickle sweetness to you.

KITTY: Let go of me. I'll scream. I'll bring the manager in and have you whipped. Have you thrown in jail you fucking black bastard. NIGGER!

SLY: Kitty. Mek me tell you. Tek a long hard look at yourself and tink straight. What man would want a desperate, ugly, bitch like you?

SLY pushes KITTY aside roughly and throws her on the bed. KITTY looks frightened as he raises his hand to hit her. He decides against it and instead, he opens her purse, takes out all of her money, pockets it and exits.

Scene 11

It is early in the morning. ANGEL is setting up her hut. She stumbles a little and sits on a chair to steady herself for a while.

NAOMI is looking for shells down by the beach. REEFIE is sat under the shade of a palm tree watching her. She turns, smiles and waves at him. He waves back.

MAGGIE approaches NAOMI.

MAGGIE: I'm all packed.

NAOMI: You don't look very well.

MAGGIE: Got the shits something chronic. Must've been something I ate. Taken some tablets to cork it all up. Now I'm feeling bloated.

NAOMI: Oh dear.

MAGGIE: Not looking forward to the plane journey… You'll be okay on your own?

NAOMI: Don't worry about me.

MAGGIE: Don't hang around here too long will you?

NAOMI: Stop fussing.

MAGGIE: Where's loverboy?

NAOMI: Getting dressed.

MAGGIE: You going to go all 'native' like your mum?

NAOMI: Don't…

MAGGIE: It won't last.

NAOMI: Never met a bloke like Andre back home.

MAGGIE: It's all an act.

NAOMI: It isn't.

MAGGIE: Only difference I see is that he's better at the game. Quite clever cos he's got you eating out of the palm of his…

NAOMI: Stop it! Don't talk about him as if he's a conman.

MAGGIE: He's after your money.

NAOMI: No. He's not like the others.

MAGGIE: How d'you know?

NAOMI: Because Andre's a good man. We'll see each other. I'll come out here, maybe he'll come and visit me. Maybe it'll all die a death – I dunno. But right this minute, now – it feels right.

MAGGIE: He will always be financially beholden to you and eventually it drives men mad. They can't cope unless they are the breadwinners.

NAOMI: He's shown me laughter and love again.

MAGGIE: Euch – you are so soppy.

NAOMI: When did you get so mean-spirited?

MAGGIE looks at NAOMI, hurt.

MAGGIE: When I faced the truth.

MAGGIE clutches her stomach and groans.

You'll call me as soon as you get back?

NAOMI: Course I will. Have a safe journey.

MAGGIE hugs NAOMI briefly and hobbles off clutching her stomach.

NAOMI watches after MAGGIE and then continues to look for shells.

Eventually, REEFIE approaches her.

REEFIE: You find any nice shells?

NAOMI: Loads. Gonna decorate my bathroom with them.

NAOMI shows REEFIE her shells.

REEFIE: Dat one dere is coral – from de reef.

NAOMI: Oh!

REEFIE: You been snorkelling?

NAOMI: Yeah. Beautiful. Really stunning. Bit scared at first. But in the end – loved it.

REEFIE: Who tek you out?

NAOMI: Andre. Some friend's boat. We were out there for ages. It's another whole world down there.

REEFIE: You have a nice time here Naomi?

NAOMI: Fantastic.

REEFIE: You going back now?

NAOMI: Leaving Negril today but I thought I'd see a bit more of the island. Just another ten days. Want to see Kingston properly and the Blue Mountains and I never made it to the Mayfield Falls.

REEFIE: You must go. You can walk up de waterfall – but you have to be careful. Mek sure you tek a guide.

NAOMI: Where's Yolanda?

REEFIE: She go back home.

NAOMI: Never got to say goodbye. Didn't even get her e-mail address.

REEFIE: Me can pass yours on.

NAOMI: Great – she was such fun. Here, I have a card. It's got my address and stuff on it.

NAOMI produces a card from her bag and hands it to REEFIE. REEFIE reads it.

REEFIE: (*Reads the card.*) You an architect!

NAOMI: Sounds more glamorous than it actually is. Only just finished training. Takes years to qualify.

REEFIE: You work in London?

NAOMI: Small firm – designing new homes. One day, I'll design something else – like a boat or a sky scraper or something like that.

REEFIE smiles.

REEFIE: So. You have a good time here.

NAOMI: This is where I was born.

REEFIE: Me hear.

Beat.

I got someting for you. A lickle present to remind you of Reefie.

NAOMI: For me?

REEFIE goes back to the palm tree and brings back a large conch shell which he hands over to NAOMI.

REEFIE: Me find it out in de sea when me go out in me boat.

NAOMI: Wow. It's stunning. Look at the colours! That's so kind of you. Thank you. I'll look at it and think of you and Negril.

ANDRE stands at some distance and waits for NAOMI. The two men clock each other warily.

REEFIE: You 'ave a safe journey now.

NAOMI: Thanks for this Reefie. I'll check you out when I come back.

REEFIE: Sure ting.

NAOMI touches fists with REEFIE. She walks up to ANDRE. He puts his arm around NAOMI's waist and kisses her. REEFIE looks at ANDRE and NAOMI together. He looks wistful.

ANDRE and NAOMI walk off together arm in arm. REEFIE watches them go.

REEFIE walks back up to ANGEL – tentatively approaching her. She looks at him haughtily.

Me sorry Angel – dat ting wid your byah – me get hot head.

ANGEL: You could hab kill him.

REEFIE: No mon…me jus' idiot…me no hurt your byah.

Beat.

ANGEL: Maybe dem hab a chance.

REEFIE is silent.

Why you not tell her? Why you hide de truth?

REEFIE looks away. He is close to tears.

REEFIE: Look at me Angel. What I am?

ANGEL: A man.

REEFIE: Me cyan admit to her…not want to disappoint her. What her fadder is. Me ashame of what I am. Me ashame.

ANGEL stands up, holds REEFIE. They stay like this for some time.

Eventually, they pull apart.

REEFIE: You okay Angel? You look tired.

ANGEL: Me jus' hear some news. Me need to sit a while.

ANGEL sits back down again.

REEFIE: Your man?

ANGEL: He die. Las' night. In him dirty room, on him own.

ANGEL looks out to sea sadly. REEFIE says nothing but goes round the back of her and massages her shoulders.

End